SONOMA

THE ULTIMATE WINERY GUIDE

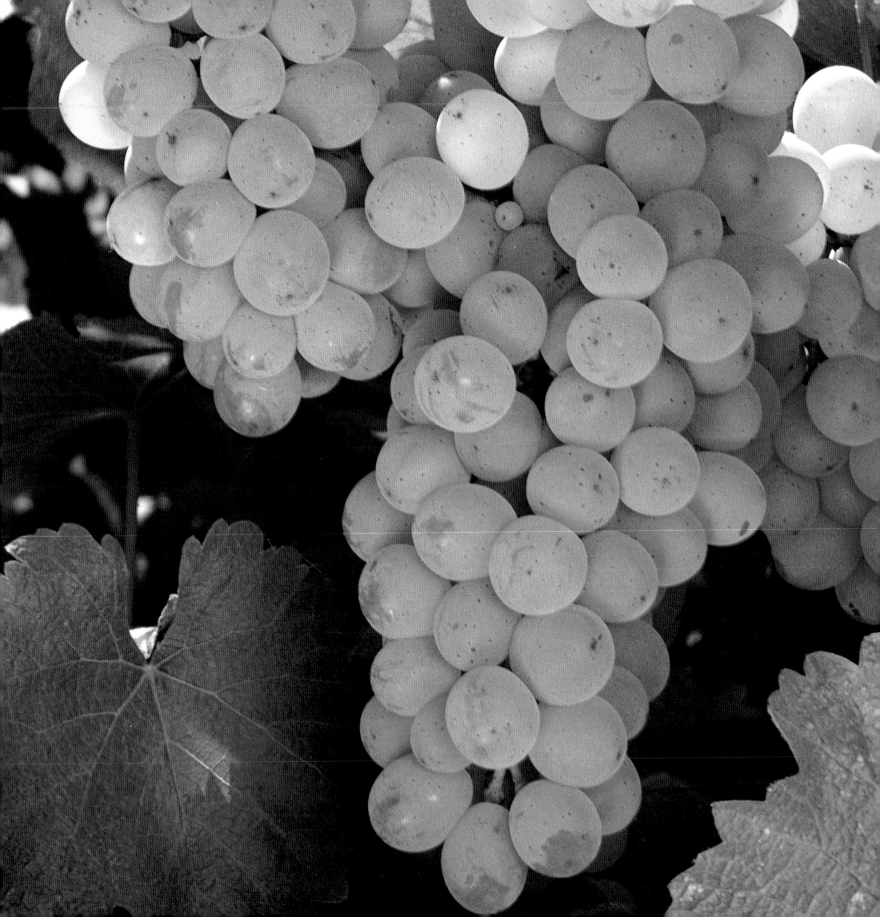

CHRONICLE BOOKS ❧ SAN FRANCISCO

SONOMA
THE ULTIMATE WINERY GUIDE

BY HEIDI HAUGHY CUSICK

PHOTOGRAPHY BY RICHARD GILLETTE

FOREWORD BY RODNEY STRONG

Library of Congress Cataloging-in-publication Data:

Cusick, Heidi.
 Sonoma: The ultimate winery guide / by Heidi Haughy Cusick;
photographs by Richard Gillette.
 p. cm.
 Includes index.
 ISBN 0-8118-0773-8
 1. Wine and wine making–California–Sonoma Valley. I. Title.
TP557.C87 1994
641.2'2' 0979418–dc20 94-34732
 CIP

Printed in Hong Kong.

Distributed in Canada by Raincoast Books, 8680 Cambie Street,
Vancouver, B.C. V6P 6M9

10 9 8 7 6 5 4 3 2 1

Chronicle Books
275 Fifth Street
San Francisco, California 94103

ACKNOWLEDGMENTS

With particular appreciation for those

whose inspiration and wisdom nurtured and

sustained our challenging task. Barry, Brendan,

and Shannon Cusick, Bob and Irma Haughy,

Antonia Allegra, Jane Benet, Dan Berger, Carey

Charlesworth, Milla Handley, Mildred Howie,

Michele Anna Jordan, Bill LeBlond, Judy Lewenthal,

Norm Roby, Sonoma County Culinary Guild,

Sonoma County Wineries Association, Marge and Bud

Canfield, Stan and Joan Gillette, Jasara and Holly

Gillette, Jason Wallach, Ray Gorman, Judi Connolly.

And a special dedication with love from Richard to

his beautiful fiancée, Amina Langedijk.

HEIDI & RICHARD

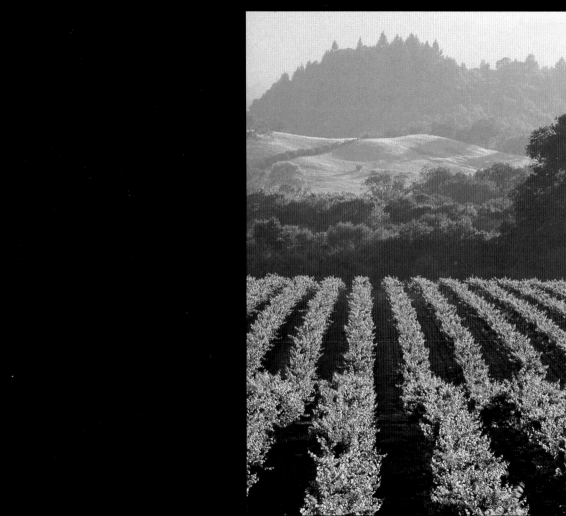

CONTENTS

FOREWORD

To the east of the great breakers and foaming surf of the Pacific Ocean lies Sonoma County. Nestled between the bracing maritime air and the warm crests of the Mayacamas Mountains, this beautiful and unique cradle is one of the best places to grow great wines in the world. That's what this beautiful book is about—the sensual delights of a rare place and the welcome it extends to you, the visitor and the native alike. ❧ The grape has been intertwined with humanity for centuries—each enhancing the quality of life of the other. ❧ The winegrowers of Sonoma County are diverse and eclectic in the pursuit of their art. The variance of climate in these small valleys, as the cool of the ocean collides with the warmth of the interior, allows winemakers to fine-tune their efforts to a degree unavailable in any other place. The early ripening grapes, such as Chardonnay and Pinot Noir, may live in the cool, redwood-scented banks of the Russian River—with the salty perfume of the maritime air streaming over the passes between the coastal hills—and in the cool nights of the gravelly loam plateaus. Big, feral Cabernet Sauvignon can be realized in the warmer regions of the Dry Creek and Alexander valleys. Zinfandel and Sauvignon Blanc excel by moving a few kilometers in either direction toward the yin and yang of the sea and the hills. ❧ It is all of this that we want to share with you. Salmon run in the streams, sheep graze on the headlands, cheese, fresh vegetables, and wild flowers abound, and rare serendipities surround you in a cornucopia of pleasure. For those of you who have not yet tasted the pleasures of this place, we encourage you to use this book as a catalyst for adventure and personal gratification. The vines, the colors of their leaves, the yeasty smells of wine in ferment, and the excitement of your own personal discoveries await you in Sonoma County. ❧ I came here in 1959 and have planted many grapes. I've pruned them and worried over them, and in return I have accepted their treasure. There is nothing better. I will travel, but I will never leave. I am here. *Join me.* ❧

Rodney Strong ❧ *Rodney Strong Vineyards*

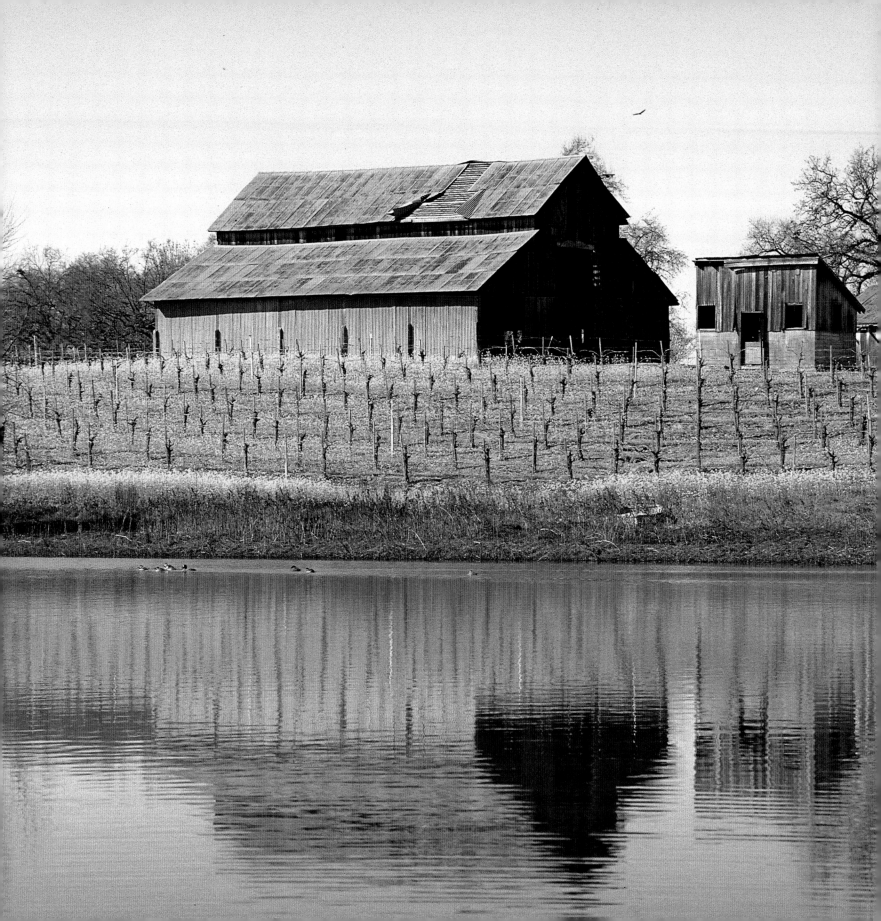

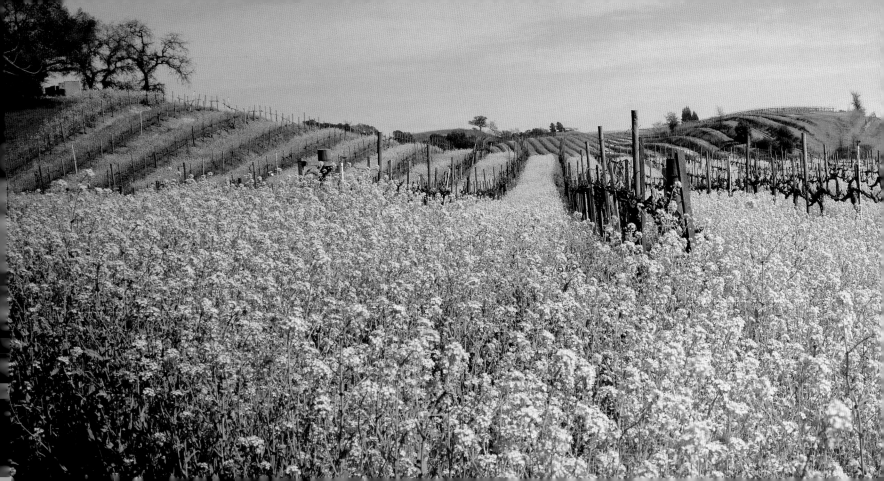

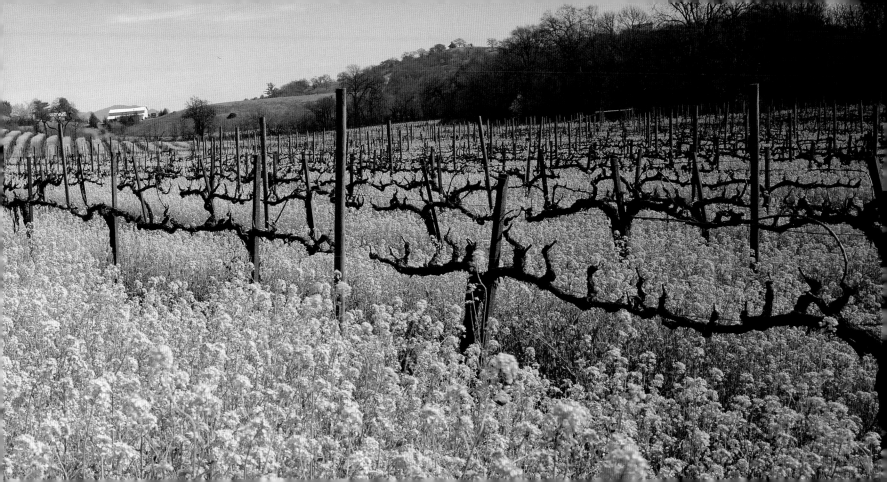

Sonoma's grape harvest begins with coastal Chardonnay picked near old-growth redwoods on cool, sepia mornings. It continues with Pinot Noir clipped in the tepid warmth of oak-studded valleys, and climaxes when cabernet clusters are cut from steep heat-trapped terraces. Sonoma County, the birthplace of American viticulture, encompasses the most diverse cross-section of geography in the California wine country. ❧ **H**ighway 101, Sonoma's marketing link to the rest of the world, divides the county down the middle. Any exit in any direction leads within minutes to a rural mix of beauty and business. ❧ **B**efore grapes were cultivated Sonoma was populated by Pomos and Miwoks, who hunted and gathered from the abundance of natural resources. The Europeans, beginning with Sir Francis Drake, arrived in the 1570s. Since then seven flags have flown over the region: English, Imperial Russian, Spanish, Mexican, Bear Flag Revolt, Californian, and the Stars and Stripes. The names of rivers, towns, and roads reflect Sonoma's heritages. ❧ **A**t the southeastern end of the county, across from the central plaza in the town of Sonoma, is the Mission San Francisco de Solano. Here in 1824, the Spanish priest Father Altimira planted grapes for sacramental wine. After the secularization of the mission, General Mariano Vallejo acquired the vineyards and, in 1841, made the first commercial wine north of San Francisco from those vines. Because the mission grapes didn't make great-tasting wine, premium winemaking had to wait until 1856, the year Agoston Haraszthy, a Hungarian exile, imported a hundred thousand grape cuttings from Europe and sold them all over California from his winery, Buena Vista. ❧ **S**outh of the oldest vineyards in Sonoma is one of California's newest appellations, or American Viticultural Areas. (Following the French, AVAs are the United States' designations of wine-growing areas identified by their particular climate and geography). Los Carneros, named in Spanish for the sheep that graze there, stretches across the southern end of both Sonoma and Napa counties on the San Pablo Bay. Pinot Noir and Chardonnay grapes grow best in this flat, windy region. ❧ **N**orth of Sonoma, above tiny Glen Ellen on Sonoma Mountain, is Jack London State Park. The Valley of the Moon, as Sonoma Valley is known, was immortalized by London's book. The name came from the local Miwoks, whose "valley of the moons" referred to the moon's appearance of setting several times over the mountain peaks. ❧ **C**ontinuing north, Highway 12 passes wineries, restaurants, and vineyards as it traverses Sonoma Valley,

nestled between the Mayacamas and Sonoma mountains. Along this route another famous author, M.F.K. Fisher, spent her last years in an adobe-style house adjacent to the Bouverie Audubon Preserve. ❧ The narrow, busy road bisects the county from the Napa border to Bodega Bay and passes through Santa Rosa, Sonoma's business, cultural, and marketing hub. It was here in 1875 that a winemaking commune, based on a utopian spiritualism called Swedenborgianism, was founded. Until Prohibition a Scotsman, Thomas Lake Harris, and his protégé Kanaye Nagasawa made wine from Cabernet Sauvignon, Riesling, and Zinfandel grapes in the Fountaingrove Round Barn, which is next to the Doubletree Hotel on a knoll overlooking the city. ❧ Famed horticulturist Luther Burbank lived in Santa Rosa for fifty years. His gardens and home, a few blocks from downtown, are open to visitors. Gold Ridge Farm, his nursery twelve miles away in Sebastopol, can be visited by appointment. Nearby, the Sonoma County Fairgrounds hosts the county fair in July and the Harvest Festival, a prestigious wine and food awards gala, in September. ❧ A growing num-

ber of fine restaurants are found in Santa Rosa, many in the downtown area near Fourth Street and others around the old Railroad Square on the west side of Highway 101. The wine list at Equus, the restaurant on Mendocino Avenue at the foot of the Fountaingrove Round Barn, features every winery in Sonoma County. John Ash and Company, one of the nation's top restaurants, is in the vineyards northwest of Santa Rosa. ❧ To the west along Highway 12 you pass apple orchards, berry farms, and horse pastures (Sonoma County is one of the largest horse breeding areas in the United States) on the way to the coast. In a region known for Gravensteins, the apple-growing heritage is celebrated with a fair in Sebastopol every August. In Sebastopol, architecture on the main street is a mix of Victorian gingerbread and 1950s functional. Several cappuccino parlors and bookstores are worth a stop, and antique hounds will love the southern stretch of Highway 116. ❧ On the coast, Bodega Bay is the second busiest salmon fishing harbor in California and is home to Sea Ridge Winery, with vineyards in sight of the Pacific. South on the Sonoma-Marin County border are the oyster beds of Tomales Bay. North is Fort Ross, where in 1812 a hundred Russians established the first European settlement north of San Francisco. They also planted the first grapes north of San Francisco with cuttings

WINE GRAPES HAVE BEEN RAISED NEXT TO VEGetables, fruits, and farm animals in Sonoma County since the Russians settled at Fort Ross in 1812. A dozen years later, when the Spanish missionaries came to Sonoma Valley, they planted olive trees, vegetables, wheat, and three thousand grapevines. The Italian immigrants brought more of the same when they settled in the northern part of the county.

"The soil here is so good. It's volcanic ash, you know. People taste more of the wines than the food right now, but it's the same thing. You don't go where there is bad soil and raise good food," said the late M.F.K. Fisher in remarks about living in Sonoma.

As you visit wineries throughout the county, you'll see vegetable farms, orchards, goat dairies, cattle ranches, poultry processors, mushroom cultivators, and roadside produce stands interspersed among the 31,475 acres of vineyards.

Various regions in the county are known for what they grow. The southwest, around Petaluma, is dairy and poultry country. The land is rich in natural grass for grazing and for raising feed. In 1920 Petaluma shipped four million pounds of butter a year and had three of the largest creameries in the West. One was the Petaluma Cooperative Creamery, which is now Clover Dairy, creator of Clo, the famous billboard cow. In downtown Petaluma the California Cooperative Creamery, parent of California Gold brand, makes award-winning butter and cheeses and has an hourly plant tour at The Creamery Store.

The "chicken capital of the world," Petaluma ships eggs by the millions of dozens. Ducks are another Petaluma specialty. In 1919, the main supplier was the Pacific Duck Ranch. Today it's Reichardt Duck Farms, which relocated from San Francisco in the 1950s and sells over a million premium ducks a year. You can buy them at the plant. For eating right away, "old-fashioned nitrite-free" smoked chicken, duck, goose,

turkey, and pheasant are available by phoning ahead to Piotrkowski Poultry, also in Petaluma.

The popular Rocky Range chickens are processed in nearby Sebastopol, which is best known for Gravenstein apples. This early-ripening all-purpose variety was introduced by the Fort Ross Russians. The first Gravenstein Apple Fair, held every year in August, was in 1910. Apples bring in more than $7 million in revenue each year; a little over $1 million is from Gravensteins. At his Sebastopol nursery, Gold Ridge Farm, Luther Burbank developed more than 800 plants, including 113 new varieties of plums and prunes.

Near Sebastopol, you'll find farm stands like Foxglove Farm on the Gravenstein Highway and Walker Apples in Graton selling apples and apple pies. On the Occidental Road, excellent goat cheese and a tour of the dairy are worth a stop at Redwood Hill Farm. Exotic mushrooms became accessible on a regular basis to chefs and markets when Malcolm Clark started farming shiitakes, oysters, morels, cepes, chanterelles, and matsutakes in a warehouse near Sebastopol.

Berries are big business in the Russian River region. Kozlowski Farms on the Gravenstein Highway carries fresh berries and apples in season, plus a mouthwatering line of preserves and condiments. Nearby on Ross Station Road, Green Valley Blueberry Farm has fresh blueberries plus ice cream, shakes, and muffins in the summer. Both are on the way to Iron Horse Vineyards.

Northern Sonoma was once a major supplier of hops to the beer industry. Grapes and produce grow in former hop fields near the Russian River, where Hop Kiln Winery is a beautiful reminder of old times. Familyowned farms and orchards abound in western Sonoma, around the Russian River, and in Dry Creek Valley. Trentadue Winery in the Alexander Valley sells produce all summer from the family's prolific garden.

Alexander Valley used to be

filled with prune, peach, and pear trees. Now, in addition to grapes, honey is a big crop. At Funnucchi's Alexander Valley Apiaries across from Alexander Valley Fruit and Trading Company, the beehives produce wildflower and eucalyptus honey.

Once the county's agricultural cradle, the town of Sonoma is now known for a variety of food processors. Mezzetta Foods, Mayacamas Fine Foods, and Sonoma Foie Gras create their specialities in this tiny metropolis. In addition to prize-winning wine B.R. Cohn presses top of the line olive oil from trees on their estate on the Sonoma Highway. Nicholas Turkey Breeders, the largest turkey breeder in the United States, is in the neighborhood, next door to Gundlach-Bundschu Winery.

Three excellent cheese producers call Sonoma home. Two, Vella Cheese Company and Sonoma Cheese Factory, have been making cow's milk cheese since the early 1930s. Laura Chenel, who pioneered the manufacturing of American goat cheese in 1980 in Santa Rosa, relocated to the old Stornetta Dairy on Napa Road outside of town. It is in the neighborhood of Gloria Ferrer, Viansa, and Cline Cellars.

Sonoma is also known for its lamb and beef, which on the hoof graze the hillsides around Healdsburg, Sonoma, and Petaluma. And every town has at least one bakery specializing in excellent French, organic, or specially flavored, crusty loaves. Names of some are mentioned in the food pairings in the Sonoma County Grapes and Wines section.

All around northern California, wine, poultry, apples, mushrooms, meats, fruit, and cheeses from Sonoma are listed on restaurant menus. Look for the Sonoma designation as well on mustard and pasta, and even on salad greens.

As you go from winery to winery, you'll notice many small local produce markets and farmstands with signs in front announcing the hours and months they too are open.

With each of the winery listings I've included the names of farms, produce markets, delis, and bakeries within a short radius. A detailed listing with a map to farms and other producers and retailers is available from the Sonoma County Farm Trails and from the Sonoma County Agricultural Marketing Program (SCAMP). See Resources "For Touring" and "For Grape Growing and Farm Produce" for their addresses.

In addition to ferreting out Sonoma's food and wine connections on your own, you can take advantage of the Sonoma County Wine and Visitors Center in Rohnert Park. The center represents 115 producers of wines and is a perfect place to be introduced to them. The center also features an extensive schedule of cooking classes taught by professional chefs. Foods from Sonoma County are featured and matched with wines. It's another example of the natural pairing of the wines of Sonoma with its foods. 🦋

A Month by Month Taster's Guide to Winemaking

GRAPES LEFT ON THEIR OWN WILL BEGIN TO FERMENT as soon as the juices break out. Yeast present on the skin consumes natural sugar in the juice and produces alcohol, flavor compounds, and the grapes are on their way to becoming wine. Centuries ago this was how wine was discovered. It sounds simple, but many other factors, such as wild bacteria, changing temperature, and incomplete fermentation, can affect the outcome. As the science and practical application of winemaking have advanced, so have the quality and control of the magical transition from grape juice into wine.

This brief month-by-month summary lets you know what is happening behind the tasting room where the finished products are shared. Basic treatments, such as racking, aging, filtering, and bottling, are included as typically applied during the winemaking process. As you tour the different wineries, individual approaches are pointed out that differ from the norm. Learning about these adds to the appreciation of what goes into winemaking and personalizes the enjoyment of each variation.

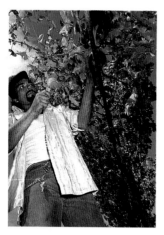

September: White grapes are picked, cooled, destemmed crushed, and juiced. Cultured yeast is added optionally, and grapes begin fermentation in stainless steel or wood. Optional addition (usually reserved for Chardonnay among the whites) of malolactic bacteria transforms the natural malic acid, which is tart, into lactic acid, which is more buttery and supple.

Red grapes are picked and optionally destemmed. Commercial yeast is added, also optionally. The grapes are fermented with skins for varying

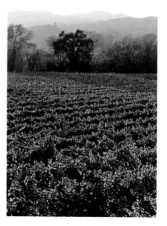

amounts of time to pick up colors; several times a day the cap of skins that rises to the top is punched down or pumped over to extract their flavor and more color. In carbonic maceration, a different fermentation technique, whole clusters are enclosed in a container without air and allowed to ferment with their own yeast. Malolactic fermentation is common with red grapes. Pressing is done from one to four weeks after harvest, depending on the style of the winemaker.

October: White-grape juice (must) samples are tested in the laboratory to determine whether fermentation is complete. The fermenting must may be stirred to mix the lees, or remaining grape solids, into the juice for more flavor.

The juice of red grapes, or must, is stored in stainless or wood. Malolactic bacteria may be added now. Samples tested in the lab determine whether fermentation is complete.

November: Newly fermented juice may be stirred to involve the lees with the wine. The clarification process begins by racking, that is, the drawing of wine from one tank into another container and leaving behind the natural sediment.

December: This is a quiet time for the wine, which is stored in wood or stainless for the next several months—the whites—or months or years—the reds. They may be stirred or racked and wines from previous vintages may be filtered, blended, or bottled. Labels might be redesigned; they and the bottles are ordered when quantities are determined, and bottling dates are scheduled for the upcoming year.

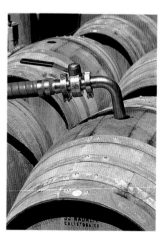

January: Wines from last September's harvest continue developing in wood or stainless; samples are tested in the laboratory to determine acid and remaining sugar levels and are tasted for flavor. Previous vintages may be filtered, blended, or bottled. Blends for sparkling wines (cuvées) may begin secondary fermentation, combined with a mixture of yeast and sugar (which creates the bubble-producing fermentation), bottled, and capped. Then they are left alone, except when being occasionally rotated, for one to three or more years.

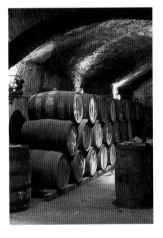

February: Sweet wines from September's harvest can be filtered and bottled. Dry wines continue development in tanks and barrels. Racking of red wines continues. Grapes are contracted for, for the next harvest. Now or any time of the year, riddling of previous vintages of sparkling wine can begin. This periodic turning of each bottle moves dead yeast cells and residue to the bottle necks, for eventual removal.

March: White wines from oak barrels may be racked now and transferred to stainless containers. The clarifying process continues by several different methods. Fining is the addition of a coagulating ingredient such as egg white (usually for red) or the natural clay powder bentonite (usually for white) which float through the wine, attract suspended particles, and draw them to the bottom. When clarified by filtering, the wine is pumped through fine screens such as those made from cellulose fibers or diatomaceous earth, which remove yeast and particulate matter. Bottling usually takes place right after filtering.

April-June: Aging of red wines continues. White wines, and also red and white wines from previous vintages, can be fined or filtered, or both, and bottled as described above. Tanks are constantly being washed and oak barrels scrubbed between uses. Previous vintages of sparkling wine can be disgorged. This is the process of freezing the bottle neck and popping off the cap to remove the dead yeast cells assembled at the cap through riddling. A dosage is then added. Dosage refers to a mixture of sugar and wine that determines whether the wine will be brut (the driest), extra dry, sec, or demi-sec (the sweetest)—and the wine is corked, secured with wire, and covered with foil.

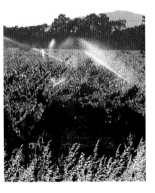

July-August: Wineries ready for the harvest. Wines are shifted from stainless and oak to other containers as necessary to allow room for new juice; new oak barrels are brought in; extra crew is hired; grapes are sampled in vineyards to determine sugar and acid levels. Bottling of previous vintages continues.

August: The harvest and crush begin, continuing into September. Grapes for sparkling wines are harvested first, followed by white and red grapes for dry table wines; Cabernet Sauvignon and botrytised grapes for sweet wines are picked last.

SONOMA COUNTY WINERIES

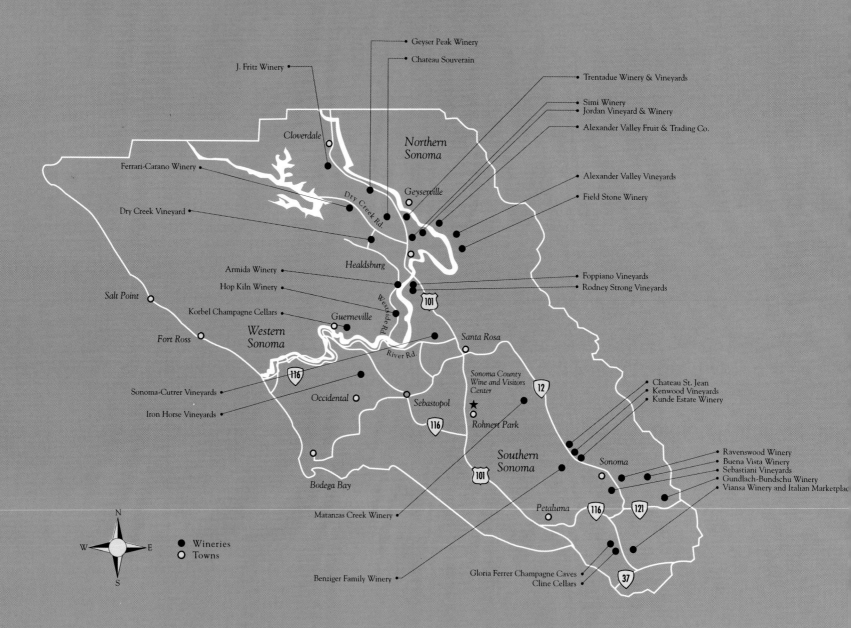

Geyser Peak Winery

Chateau Souverain

Trentadue Winery & Vineyards

J. Fritz Winery

Simi Winery

Jordan Vineyard & Winery

Alexander Valley Fruit & Trading Co.

Cloverdale

Northern Sonoma

Ferrari-Carano Winery

Alexander Valley Vineyards

Field Stone Winery

Dry Creek Vineyard

Geyserville

Healdsburg

Armida Winery

Hop Kiln Winery

Foppiano Vineyards

Rodney Strong Vineyards

Salt Point

Korbel Champagne Cellars

Guerneville

Fort Ross

Western Sonoma

Santa Rosa

Sonoma County Wine and Visitors Center

Chateau St. Jean

Kenwood Vineyards

Kunde Estate Winery

Sonoma-Cutrer Vineyards

Occidental

Sebastopol

Iron Horse Vineyards

Rohnert Park

Southern Sonoma

Ravenswood Winery

Buena Vista Winery

Sebastiani Vineyards

Gundlach-Bundschu Winery

Viansa Winery and Italian Marketplace

Sonoma

Bodega Bay

Matanzas Creek Winery

Petaluma

● Wineries

○ Towns

N W E S

Benziger Family Winery

Gloria Ferrer Champagne Caves

Cline Cellars

24

Winery Tours by Areas and Interests

By Geographic and Designated Viticultural Area

Southern Sonoma

Carneros
Buena Vista Carneros
Cline Cellars
Gloria Ferrer Champagne Caves
Viansa Winery &
 Italian Marketplace

Sonoma Valley
Chateau St. Jean Vineyards
 and Winery
Gundlach-Bundschu Winery
Kenwood Vineyards
Kunde Estate Winery
Matanzas Creek Winery
Ravenswood Winery
Sebastiani Vineyards

Sonoma Mountain
Benziger Family Winery

Northern Sonoma

Alexander Valley
Alexander Valley Fruit
 and Trading Company
Alexander Valley Vineyards
Chateau Souverain
Field Stone Winery
 & Vineyard
Geyser Peak Winery
Jordan Vineyard & Winery
Simi Winery
Trentadue Winery and Vineyards

Dry Creek Valley
Dry Creek Vineyard
Ferrari-Carano Vineyards
 and Winery
J. Fritz Winery

Western Sonoma

Russian River
Armida Winery
Foppiano Vineyards
Korbel Champagne Cellars
Hop Kiln Winery
Rodney Strong Vineyards
Sonoma-Cutrer Vineyards

Green Valley
Iron Horse Vineyards

By Ideal Visiting Seasons

Spring
Alexander Valley Fruit &
 Trading Company
Dry Creek Vineyard
Ferrari-Carano Vineyards
 and Winery
Foppiano Vineyards
J. Fritz Winery
Sonoma-Cutrer Vineyards

Summer
Armida Winery
Cline Cellars
Field Stone Winery & Vineyard
Gundlach-Bundschu Winery
Iron Horse Vineyards
Matanzas Creek Winery
Ravenswood Winery
Rodney Strong Vineyards
Trentadue Winery & Vineyards

Autumn
Benziger Family Winery
Buena Vista Carneros
Gloria Ferrer Champagne Caves
Hop Kiln Winery
Korbel Champagne Cellars
Jordan Vineyard & Winery
Sebastiani Vineyards
Simi Winery
Viansa Winery &
 Italian Marketplace

Winter
Alexander Valley Vineyards
Chateau St. Jean Vineyards
 and Winery
Chateau Souverain
Geyser Peak Winery
Kenwood Vineyards
Kunde Estate Winery

With Historical Interest
Alexander Valley Vineyards
Buena Vista Carneros
Cline Cellars
Foppiano Vineyards
Gundlach-Bundschu Winery
Korbel Champagne Cellars
Sebastiani Vineyards
Simi Winery

With Notable Offerings of Food and Sonoma Foodstuffs
Alexander Valley Fruit
 & Trading Company
Buena Vista Carneros
Cline Cellars
Chateau Souverain
 (has restaurant)
Ferrari-Carano Vineyard
 and Winery
Geyser Peak Winery
Hop Kiln Winery
Kenwood Vineyards
Korbel Champagne Cellars
Kunde Estate Winery
Ravenswood Winery
 (summer weekends only)
Rodney Strong Vineyards
Sebastiani Vineyards
Trentadue Winery & Vineyards
Viansa Winery &
 Italian Marketplace
 (has delicatessen)

With Art Exhibits
Benziger Family Winery
Buena Vista Carneros
Chateau Souverain
Ferrari-Carano Vineyards
 & Winery
Hop Kiln Winery
Matanzas Creek Winery
Rodney Strong Vineyards

WITH CHAMPAGNE / SPARKLING WINE

Chateau St. Jean Vineyards
 and Winery
Gloria Ferrer Champagne Caves
Korbel Champagne Cellars
Iron Horse Vineyards
Jordan Vineyard & Winery

WITH OUTSTANDING ARCHITECTURE

Armida Winery
Chateau St. Jean Vineyards
 and Winery
Chateau Souverain
Gloria Ferrer Champagne Caves
Ferrari-Carano Vineyards
 and Winery
Hop Kiln Winery
Jordan Vineyards & Winery
Rodney Strong Vineyards
Sonoma-Cutrer Vineyards
Viansa Winery &
 Italian Marketplace

WITH GARDENS

Alexander Valley Vineyards
Benziger Family Winery
Chateau St. Jean Vineyards
 and Winery
Cline Cellars
Dry Creek Vineyard
Ferrari-Carano Vineyards
 and Winery
Hop Kiln Winery
Jordan Vineyard & Winery
Matanzas Creek Winery
Trentadue Winery & Vineyards
Viansa Winery &
 Italian Marketplace

WITH VINEYARD VISITS

Alexander Valley Fruit &
 Trading Company
Benziger Family Winery
Field Stone Winery & Vineyard
Foppiano Vineyards
Kunde Estate Winery
Sebastiani Vineyards

WITH CAVES

Buena Vista Carneros
Ferrari-Carano Vineyards
 and Winery
Field Stone Winery & Vineyard
J. Fritz Winery
Gloria Ferrer Champagne Caves
Gundlach-Bundschu Winery
Kunde Estate Winery

WITH OUTSTANDING PANORAMAS

Armida Winery
Chateau St. Jean Vineyards
 and Winery
Chateau Souverain
Geyser Peak Winery
Gloria Ferrer Champagne Caves
Gundlach-Bundschu Winery
Iron Horse Vineyards
Jordan Vineyard & Winery
Viansa Winery &
 Italian Marketplace

WITH THE BEST PICNIC SETTINGS

Buena Vista Carneros
Benziger Family Winery
Chateau St. Jean Vineyards
 and Winery
Cline Cellars
Dry Creek Vineyard
Field Stone Winery & Vineyard
J. Fritz Winery
Geyser Peak Winery
Gloria Ferrer Champagne Caves
Gundlach-Bundschu Winery
Hop Kiln Winery
Matanzas Creek Winery
Simi Winery
Trentadue Winery & Vineyards
Viansa Winery &
 Italian Marketplace

WITH OUTSTANDING TOURS

Alexander Valley Fruit &
 Trading Company
Benziger Family Winery
Gloria Ferrer Champagne Caves
Jordan Vineyard & Winery
Korbel Champagne Cellars
Sebastiani Vineyards
Simi Winery
Sonoma-Cutrer Vineyards

WITH SELF-GUIDED TOURS

Buena Vista Carneros
Chateau St. Jean Vineyards
 and Winery
Ferrari-Carano Vineyards
 and Winery
Foppiano Vineyards
Viansa Winery &
 Italian Marketplace

WITH WINEMAKING EMPHASIS

Chateau St. Jean Vineyards
 and Winery
Gloria Ferrer Champagne Caves
J. Fritz Winery
Iron Horse Vineyards
Jordan Vineyards & Winery
Kenwood Vineyards
Kunde Estate Winery
Matanzas Creek Winery
Ravenswood Winery
Rodney Strong Vineyards
Simi Winery
Sonoma-Cutrer Vineyards

WITH CONCERTS OR THEATRICAL EVENTS

Alexander Valley Fruit &
 Trading Company
Buena Vista Carneros
Field Stone Winery & Vineyard
Gloria Ferrer Champagne Caves
Gundlach-Bundschu Winery
Rodney Strong Vineyards

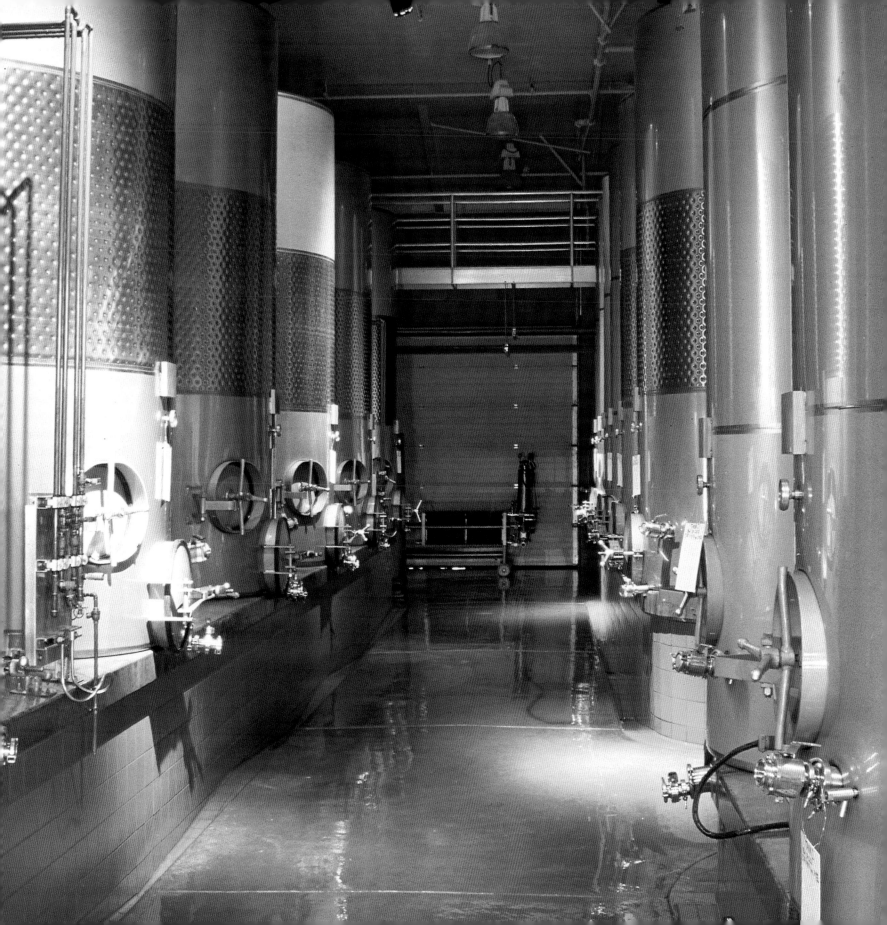

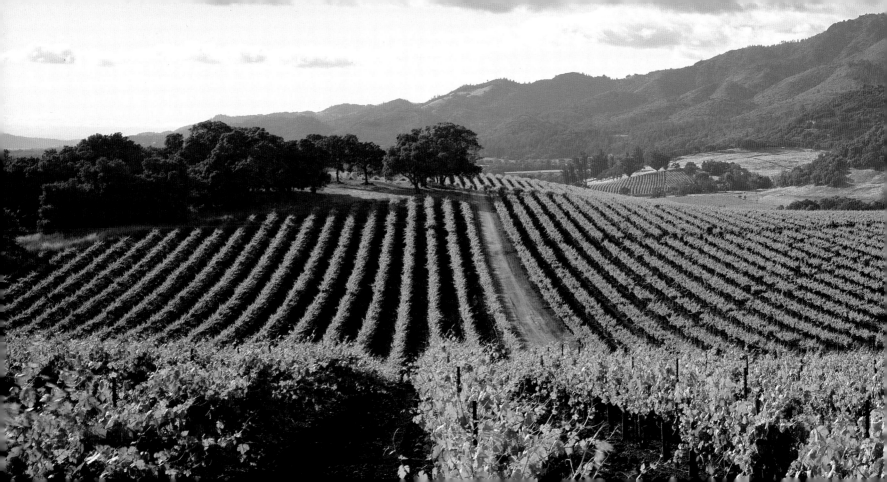

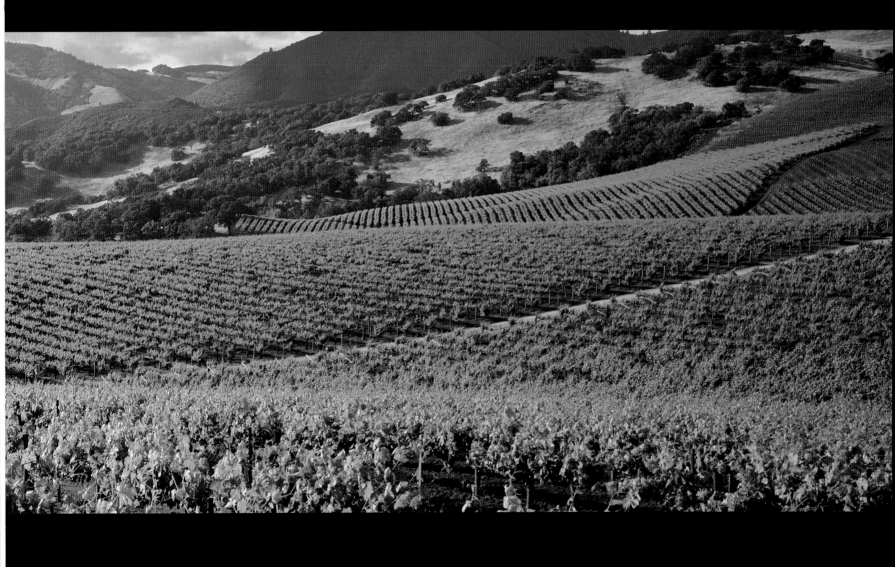

BENZIGER FAMILY WINERY

1883 London Ranch Road
Glen Ellen, CA 95442
(707) 935-3000
fax (707) 935-3016

Winemakers: Terry Nolan and
Joe Benziger

Winery owner: Benziger family

ACCESS

Location: About 1 mile from Glen
Ellen. From Sonoma take Napa Street
west to Arnold Drive, and turn right;
when you reach Glen Ellen, turn left
on London Ranch Road. Winery is up
about 1 mile on the right.

Hours open for visits and tastings:
Daily 10:00 A.M.-4:30 P.M., except
New Year's Day, Easter, Thanksgiving,
and Christmas. Winery Discovery Tour
Daily 11:00 A.M. & 2:00 P.M.;
Sonoma Mountain Estate Tour twice a
day; inquire at the tasting room for
times and reservations.

Appointment necessary for tour? Only
for Mountain Estate Tour; can be
made upon arrival at the winery. A
nominal fee, refunded with wine pur-
chase, is charged for this tour.

Wheelchairs accommodated? Yes.

TASTINGS

Charge for tasting? No.

Typical wines offered: Fumé Blanc,
Semillon, Chardonnay; Cabernet
Sauvignon, Merlot, and Imagery
Series featuring Malbec, Cabernet
Franc, and Aleatico.

Sales of wine-related items? Yes,
including shirts, books, and logo
glasses.

PICNICS AND PROGRAMS

Picnic area open to the public? Yes.

Special events or wine-related pro-
grams? Heart of the Valley Barrel
Tasting in March. Art and Wine Fair,

WHEN THE BENZIGERS MOVED FROM NEW YORK to a hundred-acre parcel west of the tiny town of Glen Ellen, they knew location was important for successful grape growing. The property, which is on the way to Jack London's ranch on Sonoma Mountain, is situated in a bowl-shaped vale, with micro-climates that nurture Sauvignon Blanc and Semillon as well as Merlot and Cabernet Sauvignon grapes.

Meandering on paths through the gardens around the old Victorian farmhouse is like being on a family estate, which is just the way the large Benziger family, including matriarch Helen, seven siblings and an entourage of in-laws, wants you to feel.

There is something to look at and ponder in every direction on the property, beginning with the "acropolis" overlooking the parking lot and the "door to nowhere" adjacent to what was once a Zinfandel vineyard.

The Benzigers coined "farming for flavor" as a way to describe the fortunate circumstances of their property. And they've created an intensive Sonoma Mountain Estate Tour to show it off. But first, you may want to get acquainted with the grounds on your own. In the parking lot you can pick up a brochure for a self-guided walking tour. It guides you to the rootstock nursery and trellis display, Bruno's nymph garden, a display of old vineyard equipment, the pond, the tasting room, and the redwood picnic grove on the original vineyard terraces, carved by Chinese laborers in the late 1800s.

A staff-guided tour, offered twice a day, begins by the old farmhouse. This tour highlights Benziger's winemaking techniques and facility. For the most advanced viticulture tour in the industry, however, the Sonoma Mountain Estate Tour takes you on an in-depth discovery of the vineyards. The motorized tour begins in front of the farmhouse. After an introduction to the winery and a stop to look at the rootstock nursery, you'll appreciate being transported up the steep hill to the acropolis for a short geology lesson. At this and the other stops around the estate, you are encouraged to touch and compare the vines and soil and to ask questions. So much information is passed on, you'll be glad there isn't an exam at the end.

The grapes that grow best in the well-drained volcanic soil vineyards are Bordeaux varieties such as Cabernet Sauvignon, Merlot, Malbec, Semillon, Sauvignon Blanc, and Cabernet Franc. No Chardonnay grows here. In addition to the eight soil types, twenty-one flavor blocks have been identified on the property. You'll learn that the Cabernet grown on this northwest-facing hill produces grapes that taste of cherry while the Cabernet on the opposite hill develops a blackberry flavor. Both exude mild herbal aromas like those from tarragon and sage.

Pruning and trellising styles are determined by amounts of sun exposure, sizes of the leaves, and angles of the hill. The Sauvignon Blanc block you see on the fourth stop on the tour grows so rigorously it develops too many leaves, which can make the flavor extremely grassy and vegetative. To tone that down the vines are trellised on a split canopy, so more fruit is exposed. The goal is to open the fruit to sunlight and increase the quality and the crop load.

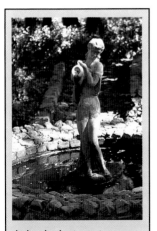

third weekend in August. Imagery Club members receive prerelease wine shipments every 3 months.

EN-ROUTE FOOD AND FARMS

Glen Ellen Village Market: deli, picnic provisions, Sonoma food items. Open daily 6:30 A.M.-9:00 P.M. At 13751 Arnold Drive, Glen Ellen; (707) 996-6728.

Oak Hill Farm: vegetables, garlic, herbs, fruit, melons. Mid-July to mid-October, Thursday-Saturday 10:00 A.M.-4:00 P.M. or by appointment. At 15101 Sonoma Highway, Glen Ellen, 95442; (707) 996-6643.

If you take the tour in the winter, you'll see the way vines are pruned. In the spring you can count the number of strings hand-tied on each cane to hold it to the trellis. In the summer you'll stand amid hot vines laden with voluptuous fruit and see how the various trellises work for each type of grape. At harvest you'll be invited to cut a cluster with the sharp, curved harvesting knife. In autumn, as the temperature changes and affects each of the microclimates, the vines reveal the differences in variety by hues, in sections of red, yellow, bronze, and gold.

After the hillside discussions, you'll proceed to the crushing and fermentation areas. The tour finishes with a component tasting in which you can sample the differences the soils make.

To the Benzigers, the narrow vineyard terraces with their concentration of diverse grape-growing conditions are like a spice rack of flavors ready for blending. On your way out, take a last look at those vines above the acropolis and think of mint, pepper, clove, sage, anise, and other herbaceous components extracted from grapes and tasted in your glass of wine. ❧

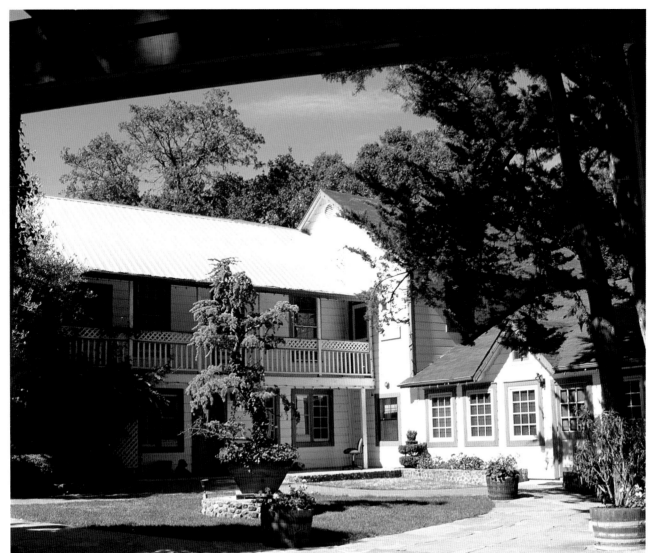

CHATEAU ST. JEAN VINEYARDS AND WINERY

CHATEAU ST. JEAN VINEYARDS AND WINERY

8555 Sonoma Highway (Highway 12)
(P.O. Box 293)
Kenwood, CA 95452
(707) 833-4134
fax (707) 833-4200

Winemaker: Don Van Staaveren

Winery owner: Suntory International, U.S. subsidiary of Suntory, Limited, of Osaka, Japan

ACCESS

Location: About 10 miles from Sonoma and 10 miles from Santa Rosa. Just north of Kenwood on the east side of Highway 12.

Hours open for visits and tastings: Daily 10:00 A.M.-4:30 P.M. Self-guided winery tour 10:30 A.M.-4:00 P.M., except New Year's Day, Easter, Thanksgiving, and Christmas.

Appointment necessary for tour? No, except guided group tours for 15 or more are available by appointment and $5.00 per person charge.

Wheelchairs accommodated? Yes, except for tour.

TASTINGS

Charge for tasting? No, except select reserve wines are $3.00 for 3 tastes and is applied to purchase.

Typical wines offered: Chardonnay, Fumé Blanc, Johannisberg Riesling, Gewürztraminer, late harvest wines and small bottlings of Muscat Canelli, Pinot Blanc, Semillon; Cabernet Sauvignon, Pinot Noir, and Merlot; Blanc de Blancs, Brut, and Grande Cuvée sparkling wines.

Sales of wine-related items? Yes, including cheese and crackers, shirts, and logo glasses; a food cart is set up in the courtyard on summer weekends.

THE ESTATE GARDENS AND MEDITERRANEAN ARCHItecture of Chateau St. Jean present a beautiful backdrop for this leading California winery. Located at the foot of Sugarloaf Ridge, the property surrounding Chateau St. Jean was part of a 19,000-acre Mexican land grant in 1837. In 1849 William Hood planted the first grapes on the ranch he named Los Guilicos.

The 250 acres that are now Chateau St. Jean's passed from Hood to L. H. Sly in the 1860s and to Ernest and Maude Goff in 1916. The Goffs came with their four children from Saginaw, Michigan and built the stately home that is now the visitor's center. The architecture and grounds with fountains and statuary preserve the refinement of a bygone era, as do the winery buildings built in 1975. This is a site to bring a picnic, a place to immerse yourself in architectural and horticultural glories.

The tour is a short self-guided photographic exhibit in the winery that begins in the fermentation room and leads you out to the crush pad—which in August and September is where you'll see plenty of action at the height of the grape harvest. High points include a detailed discussion on sugar and the cooperage exhibit.

In one of the first photographs there is a refractometer, the instrument that measures the amount of sugar in grapes to determine when they should be picked. This handy little instrument is taken into the vineyards, where the skin of a grape is punctured and juice squeezed into the tube, which is held up in the sun. It refracts differently depending on the concentration of sugar, reading out degrees of sugar on a scale known as Brix. Grapes for dry table wines are usually picked at an average of 23.5 degrees Brix unless they will be used for sparkling wine, in which less sweetness and more acid are desired.

At the far end of the exhibit, in an excellent depiction of barrel making, black and white photos show coopering as it is done in France. The display covers the process from the cutting of wedge-shaped staves to the final interior toasting, a step that enhances the oak flavor in wine.

After your brief winemaking and barrel lesson, a visit isn't complete without a climb to the top of the octagonal tower. At the top a 365-degree panorama encompasses mountains,

vineyards, winery equipment, and the lovely grounds below. The vines you see on the steep volcanic hillside to the east are a quarter of an acre of Cabernet Sauvignon.

When you descend and come out of the tower, be sure to have a look at the barrel room through the smoke-tinted viewing window. On each barrel you can read the name of the vineyard, the vintage, the date it was filled, and the tank it came from. This is significant because Chateau St. Jean, under the direction of the first winemaker, Dick Arrowood, pioneered the separation of vineyard lots and ultimately the labeling of certain wines by their vineyards. Chateau St. Jean was the first winery built to accommodate a multitude of small lots.

The winery was founded in 1973 by table grape growers from the San Joaquin Valley, Robert and Edward Merzoian and Kenneth Sheffield. They purchased the property from the Goff estate and named it after Jean Sheffield Merzoian. In 1990, after Chateau St. Jean was sold to Suntory International, Dick Arrowood left to make his own wine at Arrowood Vineyards a few miles south of here. His former assistant, Don Van Staaveren, continues producing the varietal and vineyard-designated wines.

In the elegantly appointed visitor's center, once the Goffs' living room, compare Chardonnays from Robert Young and Belle Terre vineyards and see if one is fruitier or drier or if you can taste any oakiness. The knowledgeable staff can also introduce you to Chateau St. Jean's Brut sparkling wine, made in Graton in western Sonoma County.

Then, plan to meander around the courtyards and flower gardens on both sides of the house. The Goffs counted Luther Burbank a friend, which may explain the exotic plantings of palm, pomegranate, coffee, tea, and cork trees interspersed with the formal gardens and fountains. The grandiose stretch of lawn to the west and the picnic tables under pines contribute to the romance of this beautiful setting. As you stroll to or from the chateau, stop to admire the two small ponds in front. The Goffs designed them in the shapes of Lake Michigan and Lake Huron to remind them of home. The statue of the young woman was designed in 1980 from a photograph of the winery's namesake. ❧

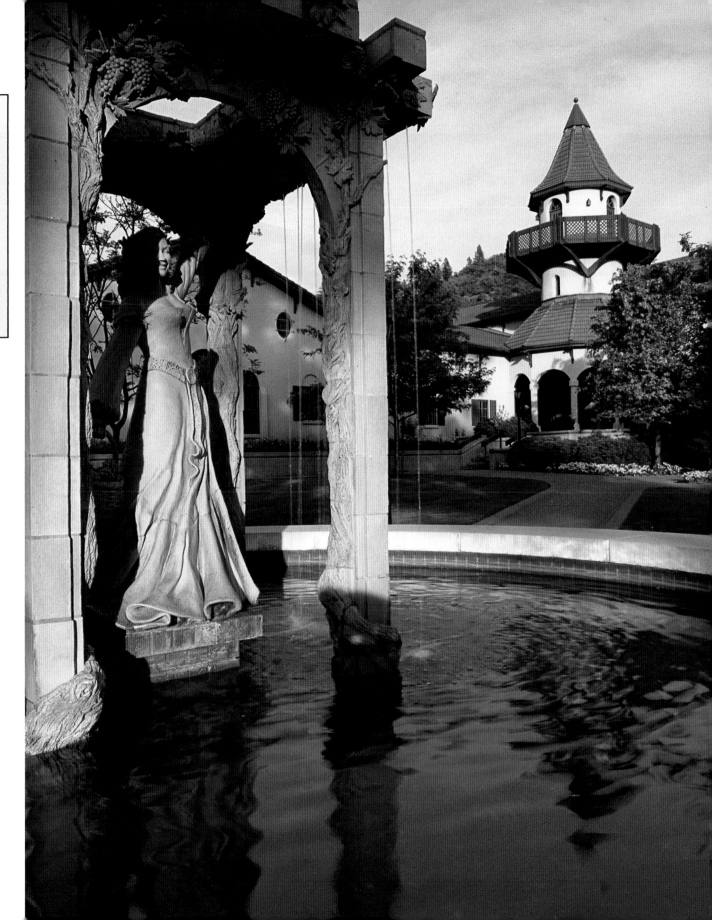

PICNICS AND PROGRAMS

Picnic area open to the public? Yes.

Special events or wine-related programs? Heart of the Valley Barrel Tasting in March. Fête du Chateau barbecue and charity fundraiser in July.

EN-ROUTE FOOD AND FARMS

Buchanan Ranch Country Store: organic produce, cheeses, Sonoma products, picnic fare. Open daily 9:00 A.M.-6:30 P.M. At 9255 Sonoma Highway, Kenwood; (707) 833-5153.

Also see Kenwood and Kunde.

CLINE CELLARS

CLINE CELLARS

24737 Highway 121 (also Carneros Highway, Arnold Drive)
Sonoma, CA 95476
(800) 546-2070 or (707) 935-4310
fax (707) 935-4319

Winemaker: Matt Cline

Winery owners: Fred and Nancy Cline and Matt Cline

ACCESS

Location: About 6 miles south of Sonoma. From Highway 101 take Highway 37 east, then take Highway 121 (Arnold Drive); north 4½ miles, turn left at the entrance (opposite Viansa Winery).

Hours open for visits and tastings: Daily 10:00 A.M.-6:00 P.M., except Thanksgiving and Christmas.

Appointment necessary for tour? Yes.

Wheelchairs accommodated? Yes.

TASTINGS

Charge for tasting? No.

Typical wines offered: Semillon, Muscat Canelli; Rosé; Zinfandel, Carignane, Mourvèdre, Cotes d'Oakley (Rhône blend).

Sales of wine-related items? Yes, including cheese and crackers, and other Sonoma food items.

PICNICS AND PROGRAMS

Picnic area open to the public? Yes.

Special events or wine-related programs? Theme winemaker lunches at family ranchhouse once a month in summer. Chocolate Festival in November. Pendulum Wine Club members receive wine shipments, special discounts, reserve tastings, limited and library release announcements, invitation to special parties and events. Outdoor lawn area and indoor arena available for weddings and other catered events for up to 1,000 people.

IN THE HEART OF THE CARNEROS, FRED CLINE AND HIS brothers, enologist Matt and landscape architect Mike, are stewarding one of southern Sonoma's treasures. Once the site of a Miwok village and later the first, temporary Mission San Francisco de Solano, this is a winery where you can enjoy a picnic and a whole afternoon.

The most beguiling features of the former Rancheria Pulpuli, which was part of the Mexican land grant of Petaluma, are the six spring-fed ponds. Established in the 1880s by Mr. J. A. Poppe, these are the oldest farm-raised carp ponds in California. Carp still flash their golden sides but are raised strictly for pleasure these days. Mr. Poppe imported the original carp from his native Germany and sold them for a dollar a pound in 1882. Children love to see them and the snapping turtles that bask lazily on floating logs.

Start your walk from the tasting-room side of the ponds. After a short distance, you'll come upon an old bath house that straddles one of the streams. Inside, the menthol aroma of eucalyptus berries scents the steamy air and a natural warm spring feeds the built-in tub.

This spring is probably what attracted the first settlement of Miwoks and later the missionaries. Father José Altimira wrote about them in a diary entry around the time he erected a cross on the site, July 4, 1823. Carving initials in wood is a custom honored in these weathered walls. See if you can find a date earlier than J.W. Robb's 1877.

From the bath house the trail passes a handmade domed willow hut, a reproduction of one used by the original inhabitants. It is a beautiful structure that needs only a mud covering and animal skins on the floor to make it a snug place to sleep. On the circular route back to the ponds, old grapevine and willow prunings are arranged in stacks, ready for building another hut or kindling a fire for an evening meal. Keeping nostalgia in perspective, the cinder block and corrugated steel winery shortly comes into view. Crushing and stemming equipment in front are reminders of where you are.

At harvest time trucks roll in loaded with Zinfandel, Mourvèdre, and Carignane grapes grown in Oakley at the Cline family's vineyards. The reestablishment of the Clines

from Contra Costa, where they built a sterling reputation for their Rhône-style grapes and wine, to Carneros is a matter of salesmanship, luck, and discernment.

Fred Cline is the oldest of nine children and the grandson of Valeriano Jacuzzi, inventor of the pump spa. Grandpa Jacuzzi settled in the Sacramento Delta and planted the 350 acres in Oakley a hundred years ago. When he died, Fred, who was raised in Los Angeles, moved to the ranch to help his grandmother and earn his viticulture degree at the University of California, Davis. In 1982 he used his twelve-thousand dollar inheritance to establish a winery. Realizing he was not on a route that lures a steady stream of visitors, he looked to the Carneros and was able to purchase this foreclosed 350-acre ranch at a bargain in 1989. Fred and his wife Nancy moved to the property and live in the hillside ranch-style home with their five children. They built the winery in 1991.

Most of the grapes for the 25,000 cases of Cline wines come from the Oakley vineyards. More Rhône varieties such as Marsanne, Viognier, Alicante Bouschet, and Syrah are being planted here next to the already known to be Carneros-

EN-ROUTE FOOD AND FARMS

Laura Chenel's Chevre: goat milk and variety of fresh and aged goat cheeses. Open and tours given by appointment. At Highway 121 and Napa Road, Sonoma; (707) 996-4477.

The Cherry Tree Deli: picnic provisions, fruit, and vegetables. Open daily 6:00 A.M.-8:00 P.M. At 1901 Fremont Drive (Highway 121), Sonoma; (707) 938-3480.

Also see Gloria Ferrer and Viansa.

loving Chardonnay and Pinot Noir. The Carignane, Mourvèdre, and above-mentioned varietals grow in the 125-mile region along the Rhône River in southern France. The grapes produce mostly red, affordable wines that are meant to be drunk young, but can be aged. In 1991, Fred and Matt Cline, along with other producers of these wines, formed a loose-knit group of self-proclaimed Rhône Rangers to promote them.

The hearty reds are aged in French oak for over a year, which adds to their "dusty berry" flavors and aromas. Try one with a chocolate turtle in the jar on the bar in the tasting room and you'll know why Cline hosts a chocolate festival in November.

Around the porch of the 1850s farmhouse miniature roses bloom ten months of the year. Over two hundred rose varieties are included in the thousand planted on the property. Ask the staff about the roses, a popular planting around vineyards in both France and California. You'll learn that they are practical as well as beautiful. In a damp climate roses tend to mildew before grapes, making them valuable for identifying diseases that might strike the vines. As for beauty, roses have the most blossoms per square inch of any landscape plant and they bloom from March until October.

To smell the roses or sip the wine, this is a magical spot. The Clines' determination to preserve and share a historical site is itself an act of beauty. 🐝

GLORIA FERRER CHAMPAGNE CAVES

23555 Highway 121 (also Carneros
Highway, Arnold Drive)
(P.O. Box 1427)
Sonoma, CA 95476
(707) 996-7256
fax (707) 996-0720

Winemaker: Bob Iantosca

Winery owner: Ferrer family

ACCESS

Location: About 5 miles south of
Sonoma on Highway 121 (Carneros
Highway). From Highway 101 take
Highway 37 east to Highway 121
north. Winery is in about 5 miles,
on the left.

Hours open for visits and tastings:
Daily 10:30 A.M.-5:30 P.M., except
New Year's Day, Thanksgiving, and
Christmas. Winery tours on the hour
11:00 A.M.-4:00 P.M.

Appointment necessary for tour? No.

Wheelchairs accommodated? Yes.

TASTINGS

Charge for tasting? Yes, variable.

Typical wines offered: Brut and other
cuvées of sparkling wines;
Chardonnay; Pinot Noir.

Sales of wine-related items? Yes,
including glasses, books, and cookies.

PICNICS AND PROGRAMS

Picnic area open to the public? Yes.

Special events or wine-related pro-
grams? Monthly events; call winery
for current schedule.

EN-ROUTE FOOD AND FARMS

Angelo's Country Deli: meats and
cheeses, jerky. Open daily 9:00 A.M.-
6:00 P.M. At 23400 Highway 121,
Sonoma; (707) 938-3688.

John's Fruit Basket: fresh seasonal
produce, sodas; Open daily 7:00 A.M.-
7:30 P.M.; 24101 Highway 121
(Arnold Drive), Sonoma;
(707) 938-4332.

A SPANISH CULTURAL REVIVAL CAME TO SONOMA when Gloria Ferrer Champagne Caves opened in Carneros. The Ferrer family's emphasis on their heritage is evident in the winery's architecture, hospitality, and schedule of events.

In the 1600s, when their fellow countrymen were exploring the new territory that was to become California, Gloria Ferrer's parent company had already been making wine for three hundred years in Sant Sadurní d'Anoia, a Catalonian town near Barcelona. Still a family-run company, Freixenet (pronounced fresh-e-net) is the world's largest producer of *méthode champenoise* sparkling wine. José Ferrer, who heads the Freixenet companies, including wineries in Spain, France, and Mexico, named his Sonoma cellars after his wife and partner, Gloria. Their son José Maria Ferrer, who runs Gloria Ferrer Champagne Caves,

says, "It's important that we bring our Spanish heritage with us, no matter where we go in the world."

Amid the vineyards the winery resembles a Spanish monastery on a California hill. Red barrel roof tiles, creamy adobe walls, and intricate wrought-iron and woodwork throughout establish the ancestry of the design.

As you climb the stairs and walk along the porch you may feel a pervading aura of sanctity and even half-expect brown-frocked padres to pass in prayer. Any too-solemn thoughts in this beautiful cloister, however, tend to quickly reorient in the tasting room.

Alongside the serious business of winemaking, the hospitality staff work full time putting on programs and celebrations, mostly with a Spanish emphasis.

In January, "El Día de Los Reyes Magos," the Feast of the Kings, is celebrated on the first Sunday of the year. It's a Spanish version of Twelfth Night. This is commemorated with a procession of richly attired kings and a performance of the Sonoma Valley Choral Chamber Ensemble. A strictly Catalan holiday is celebrated in April in honor of Saint Jordi, the patron saint of Catalonia. The yearly schedule continues with concerts, a Mother's Day brunch, Catalan cooking classes, a Halloween extravaganza, and a daily agenda that includes tastings and hourly tours of the winery.

The tour includes an unforgettable visit to the caves. It begins on the porch, where the guide explains that the low roof and thick archways typically surrounding Spanish buildings are designed as a cooling buffer against summer heat.

At the nearby crush pad the presses are used to extract juice from Chardonnay and Pinot Noir grapes. The gentle pressing of small lots is a typical *méthode champenoise* technique. Grapes for sparkling wine are among the first picked in the season because the first have less sugar and higher acid, both of which are desirable for making premium sparkling wine.

Inside the winery, a visitor's room overlooks the bottling and disgorging line. A short video on blending and a quick demonstration of riddling precedes the descent into the 100-foot-long cave, where the initial ambience of hallowedness resumes. This time it is evoked by dim light and the glint of a hundred thousand bottles. In the background the rhythmic

Sonoma Foie Gras: Muscovy duck liver, mousse de foie gras, *magret* (breast fillet), legs for confit, duck fat. Call for an appointment. 1905 Sperring Road, Sonoma (about 4 miles from winery); (707) 938-1229. Also see Cline and Viansa.

dut-dut of an invisible riddler reverberates like a solo Gregorian chant. An eighth of a turn, an eighth of a turn; 6,250 bottles an hour every day for four to five weeks. One-fourth of the wine here is riddled by hand. The rest is machine riddled, which takes less than one week. Before ascending the stairway, look out over the grand arched cave where each bottle spends two-and-a-half to five years, developing bubbles and flavor. It's too bad the wine can't appreciate the ethereal beauty of the surrounding chamber.

In contrast the bright daylight outside will jolt your senses and on a hot day may create the sensation that you've stepped into an oven. For rejuvenation, a visit to the tasting room and pause on the terrace are in order. If you've packed a picnic this is a spectacular place to eat. The view encompasses the whole of the Carneros, extending from the fertile sandy vineyards below to Mount Diablo in the southeast, the entrance to Napa Valley to the east, and Sonoma Mountain to the north.

Before you depart, a Catalan toast may be offered when one of the staff raises a glass and says with typical Ferrer hospitality, *Salut! I que per molts anys puguem disfrutar-la!* To our health! And many years to be able to enjoy it! 🦌

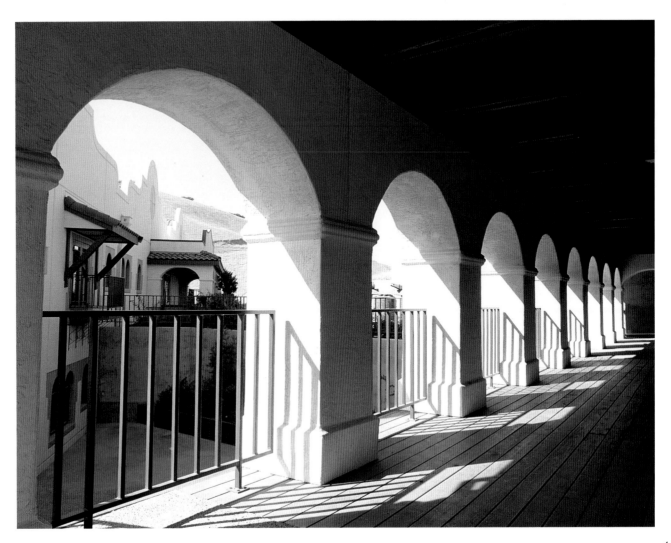

GUNDLACH-BUNDSCHU WINERY

2000 Denmark Street
Sonoma, CA 95476
(707) 938-5277
fax (707) 938-9460
Winemaker: Linda Trotta
Winery owner: Jim Bundschu

ACCESS

Location: About 2 miles east of Sonoma. From Sonoma take Napa Road East and turn right on Eighth Street East. Turn left at Denmark and continue around the sharp right angle. The driveway is on the left.

Hours open for visits and tastings: Daily 11:00 A.M.-4:30 P.M. except New Year's, Easter, July 4, Thanksgiving, and Christmas.

Appointment necessary for tour? No formal tours.

Wheelchairs accommodated? Yes.

TASTINGS

Charge for tasting? No.

Typical wines offered: Chardonnay, Gewürztraminer, Kleinberger, Riesling; Cabernet Sauvignon, Merlot, Pinot Noir, Zinfandel.

Sales of wine-related items? Yes, including shirts, logo glasses, and copies of the posters.

PICNICS AND PROGRAMS

Picnic area open to the public? Yes.

Special events or wine-related programs? Shakespeare Festival on Friday, Saturday, and Sunday nights from mid-June through September (bring picnic, chair, sunglasses, and blanket). Wine of the Moment Club members receive wine shipments, special discounts, and notices of new and library wine releases.

THE FOUR HUNDRED ACRES OF GUNDLACH-Bundschu's Rhinefarm extend from the Mayacamas foothills like a big welcome mat. In the summer clusters of poppies line the one-lane rough-riding driveway that extends between vineyard rows of nearly a dozen vine varieties. Directly ahead is the family's Rhine-style house, a lovingly kept vestige of the property's history. If you think this visit to one of California's oldest vineyards will be a sentimental journey into the past, as you turn left and head up the hill you are in for a surprise.

Those familiar with Gundlach-Bundschu's playful advertising posters know that interplay of old and new, of wit and audacity come with the territory. The first of these is exemplified by a vibrant contemporary mural at the back of the 130-year-old stone cellar. Painted by San Francisco muralists Eduardo Peneda and Ray Patlan, the scenes celebrate the Mexican-American contributions to California winemaking. In the last panel, founders Jacob Gundlach and Charles Bundschu are barbecuing a few wursts for a harvest party. Vignettes from the mural have been reproduced as labels for reserve wines.

Around the corner the lichen-covered stonework and an old mission bell effect a nostalgic façade. A plaque over the door establishes bonded winery number 64 as the sixty-fourth winery in California to receive its operating license. Inside, a hodgepodge of memorabilia, awards, and the posters that con-

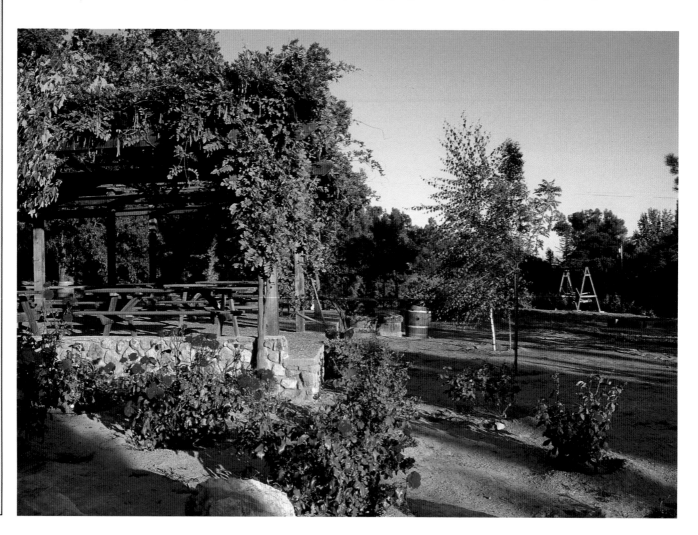

EN-ROUTE FOOD AND FARMS

Hollyhock House: apples, pears, plums, figs, vegetables. Hours by appointment. At 1541 Denmark Street, Sonoma; (707) 938-1809.

Vineburg Country Market: picnic fare, Mezetta olives and condiments. Open Monday-Friday 6:00 A.M.-7:00 P.M., Saturday 8:00 A.M.-5:00 P.M., closed Sunday. At 1013 Napa Road, Sonoma; (707) 996-5797.

Also see Sebastiani, Ravenswood, and Buena Vista.

tinue to attract attention are crammed into the lively tasting room. Usually a wild and rhythmic CD is playing contemporary rock, jazz, or blues. On the walls are copies of the poster ads, which are known for carrying a play on Gundlach-Bundschu's name or a parody on drinking. At the bar or from a brochure you can learn the winery's story.

In 1858 Jim Bundshu's great-great-grandfather, Jacob Gundlach, along with fellow German Rhinelander Emil Dresel bought this acreage and began planting grapes. In 1875 Gundlach brought in Charles Bundschu, his future son-in-law, as a partner, and they made and bottled Bacchus Wines. Schooners came up Sonoma Creek at high tide, picked up the wine in barrels, and took it to be aged and bottled at the warehouse in San Francisco, where the two families lived.

Everything went along well until 1906, when the earthquake and fire demolished the warehouse and all the inventory. The Gundlach and Bundschu families moved to the Rhinefarm, where they made wine until Prohibition. Then, for the next sixty years, the family concentrated on farming. They added cattle and pears to the vineyards and sold grapes to Inglenook, Martini, and Sebastiani.

The return to winemaking came in the late 1960s when Jim Bundschu and his father, Towle, converted the whole ranch back to wine grapes. At the time the old stone winery had only three walls remaining, and it had to be rebuilt. In 1973, Gundlach-Bundschu Winery was reestablished and produced six hundred cases. Now production is up to fifty-thousand cases, and twelve different wines are made from grapes grown on the farm.

To accommodate so many wines, the bottling line, right inside the front door of the tasting room, could be rattling along any time you visit. An air of humor keeps everything light and fun, especially when Jim Bundschu's Sonoma Wine Patrol has recently perpetrated another escapade. His raiders have been known to invade the Napa Wine Train and run through the cars pouring Sonoma wines. They've also hijacked a bus of travel writers in Napa and diverted it to Gundlach-Bundschu.

Directly across from the tasting room is the ten thousand-

square-foot subterranean cave for barrel storage and aging that was completed in 1991. Windows on the doors allow you to see down the gunnite-covered tunnel to an aisle of some of the 1,800 French and American oak barrels inside.

For a superb angle on Sonoma Valley take the "short strenuous hike" over the caves to the top of the hill. The trail is quite steep, so wear comfortable shoes, and watch out for poison oak. On any weekend, the grounds around the winery feel like a community park. Picnickers are everywhere—hiking, lounging on the hillsides, sitting next to the pond. Theatrical events are performed on summer evenings in the natural amphitheater.

The spirit of hospitality here is as generous as the business of making the wine is serious. An uncompromising boldness, especially in the highly rated red wines, is a tangible reflection of the style that has evolved through six generations of Gundlachs and Bundschus, punctuated with an indispensable sense of humor. ❧

SOME PEOPLE HAVE A QUIET KNACK FOR LEADING THE competition. In 1970, brothers Marty and Mike Lee and brother-in-law John Sheela talked the Pagani brothers into selling their jug winery in Sonoma Valley. The three established Kenwood Vineyards and became forerunners of the 1970s influx of wine boomers in Sonoma County.

Learning as they went the partners transformed a bulk wine operation on the east side of Sonoma Valley into this state-of-the-art, award-winning winery. Before you go inside the weathered redwood tasting barn, check the marquee in front for the list of wines being poured. If it's a weekend, one of Kenwood's famous appetizers will also be listed, such as mushrooms and Chardonnay or focaccia and Pinot Noir. Then step through the old sliding door into one of Sonoma's most hospitable tasting rooms.

In addition to being conversant on the history and wines of Kenwood, the staff is trained in the guidelines of the Responsible Hospitality Coalition. This means tastings are

limited to four or five single ounces, about as much as an average person can metabolize in an hour, the time of a normal winery visit. Water and crackers are always available, and so is mineral water for the designated driver.

Posters and pamphlets on wine and health issues are for sale in the tasting room. So is Kenwood's cookbook, *The Mediterranean Collection*, with recipes from the winery staff based on grains, vegetables, a little meat, and olive oil.

You'll have to call ahead to make arrangements for a tour of this facility that makes one of America's most popular Sauvignon Blancs and has exclusive rights to the grapes from Jack London's nearby ranch.

"Most of our wines are fermented in stainless tanks," says the guide as you enter the fermentation room. Stainless allows a controlled fermentation, which aids the winemaker in producing consistency from vintage to vintage. After fermentation, complexity is developed by aging in barrels and by the cuvée method of blending lots.

On the tour, someone asks about the tanks, which are similar to those in all wineries. Jackets around them, also made of steel, hold glycol-filled coils that can be chilled or warmed to keep the temperature of the contents stable. Each of the tanks in the first room holds five to six thousand gallons. In the second room, the tanks are twice as big. The entire winery has a 900,000-gallon capacity, which is about 220,000 cases.

From the fermentation rooms you step outside next to the hillside Chardonnay vineyard. The vines here are eighteen years old, middle-aged for Chardonnay which peak out between thirty and thirty-five years. From then production goes down, so the vines typically are replanted or grafted. Although these vines aren't old, among them you'll see new plantings. This is because of phylloxera. Replanting with phylloxera-free rootstock before the vines die will help the vineyards meet future demand without any shortages.

The tour winds up in the original Pagani Brothers winery adjacent to the tasting barn. If you are used to barrel rooms with stacks of small oak barrels, this is an impressive display of another kind of oak aging. Each of the 1,200- to 2,900-gallon tanks were hand-coopered in France, dismantled, numbered,

EN-ROUTE FOOD AND FARMS:
Cafe Citti: Italian-style trattoria, sandwiches, picnic supplies, and Sonoma products. Open Sunday-Thursday 11:00 A.M.-9:00 P.M., Friday & Saturday 11:00 A.M.-9:30 P.M.; At 9049 Sonoma Highway, Kenwood; (707) 833-2690.

Kenwood Produce: self-service farm stand with seasonal produce, nuts, and melons. Open June-November 8:00 A.M.-dark. At 587 Adobe Canyon Road, Kenwood; (707) 833-5583.

Also see Kunde, Chateau St. Jean, and Benziger.

and reassembled in the room, and each is a little different. Because of their size they impart much less oak flavor to the red or white wine inside than their smaller counterparts. The regular barrel room is in another building, across the entryway from the tasting room. It is opened to the public in March, when wineries in the valley sponsor a barrel tasting for the American Heart Association.

Until March, you can sample the current releases. Two specialties of Kenwood are the artist series and the Jack London–ranch wines.

If you come in December you'll be amazed at the Festival of Lights, a fundraiser for the Coalition against Hunger. All of the wineries in Kenwood decorate for the season and it's quite a display. 🐾

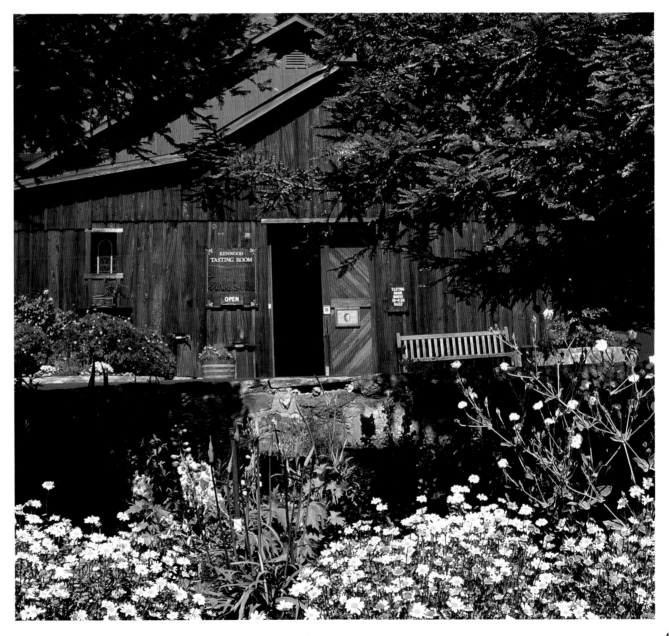

MATANZAS CREEK WINERY

MATANZAS CREEK WINERY

6097 Bennett Valley Road
Santa Rosa, CA 95404
(707) 528-6464
fax (707) 571-0156
Winemakers: Susan Reed and
Bill Parker
Winery owners: Sandra and
Bill McIver

ACCESS

Location: Between Sonoma Valley and
Santa Rosa, in Bennett Valley. From
Highway 101 north- or southbound,
take Highway 12 (Sonoma off-ramp)
to "South E Street Downtown" and
stay in the right lane; this becomes
Bennett Valley Road. Winery is on the
left about 5 miles from the freeway.

Hours open for visits and tastings:
Monday-Saturday 10:00 A.M.-4:00
P.M., Sunday 12:00 P.M.-4:00 P.M.
Closed New Year's Day, Thanksgiving,
and Christmas. Self-guided garden
tour 10:00 A.M.-3:30 P.M.

Appointment necessary for tour? Yes
for winery, not for garden tour.

Wheelchairs accommodated? Yes.

TASTINGS

Charge for tasting? No.

Typical wines offered: Chardonnay,
Sauvignon Blanc; Merlot.

Sales of wine-related items? Yes,
including lavender bouquets and toi-
letries, logo glasses, T-shirts, art.

PICNICS AND PROGRAMS

Picnic area open to the public? Yes.

Special events or wine-related pro-
grams? Annual black chefs' fundraiser
with Sonoma's 100 Black Men service
club in August. Bennett Valley Days,
August. Matanzas Wine Club includes
prerelease program, wine discounts,
and advance notice of winery dinners
and tastings.

BEGINNING IN JUNE AT MATANZAS CREEK WINERY, the blooms of five thousand French lavender plants scent the air like an herbaceous sauna. The rest of the year, the silvery spiked tufts present three acres of texture against a palette of native and aromatic plantings.

The gardens and zenlike winery created by Sandra and Bill McIver provide a rich setting for the equally rich Bordeaux-style wines they produce. Matanzas Creek is the only winery in the bucolic Bennett Valley, where cattle ranches still abide, and where the Grange Hall, built in 1873, is the oldest in the United States. Bennett Valley Road, one of the most serene lanes in the county, connects Santa Rosa, just ten minutes away, with Sonoma Valley to the east.

Heading up the narrow straight driveway you'll have to go slowly and pull over for oncoming cars. A massive redwood fountain, sculpted by Bruce Johnson of Santa Rosa, marks the right turn to the winery.

The guided tour, which is by appointment, is supplemented by a self-guided tour of the grounds which can be taken any time by picking up a brochure in the tasting room. The guided tour begins on the terrace. Inevitably the lavender, blooming or not, sparks the first discussion. Grosso is the dark blue variety, used mainly for oil; Provençal is the most aromatic; and Dutch has flowers all the way down its very long stem. As soon as the bottom flower opens, between mid-June and July, the lavender is harvested and hung upside down in the hay barn to dry. Bouquets are sold in the tasting room along with a variety of lavender-scented toiletries.

Before leaving the terrace, be sure to notice the ingenious downspout that looks like a huge chain hanging from the roof.

En-route Food and Farms:

Traverso's Gourmet Foods & Wine: Italian deli, picnic supplies, Sonoma food items. Open Monday-Saturday 11:00 A.M.-8:00 P.M. At 106 B Street, Santa Rosa; (707) 542-2530.

Imwalle Gardens: seasonal produce since 1886. Open all year, Monday-Saturday 8:30 A.M.-5:30 P.M., and February-November, Sundays 11:00 A.M.-4:00 P.M. At 685 West 3rd, Santa Rosa; (707) 546-0279.

Calamity Acres & Hogwild: dairy goats, meat kids, rabbits, turkeys, sheep, lambs. Open all year by appointment. At 1682 Ludwig Avenue, Santa Rosa (about 7 miles from the winery); (707) 575-5653

Inspired by a Japanese design, the winery's architect, Paul Hamilton, incorporated this system as an attractive way to direct the almost daily drip of condensation from the roof. Aesthetic details like this are evident throughout the winery.

Inside the winery, across from stacks of wine cases is the "Wall of Knowledge," a display of photos and memorabilia, plus maps of the area. An infrared photograph measures the contour of vines in the ever-constant vigil for phylloxera damage. Infrared shots are taken from airplanes each year as a means of singling out a color or contour change that could point to the little louse's destructive arrival.

At the far end of the warehouse, a window opens to the laboratory. Usually one of the two winemakers, Susan Reed or Bill Parker, will be there sampling and testing. Inside is the first example of the state-of-the-art equipment you'll see throughout the winery. The counter-top spectrophotometer is a ten-thousand-dollar instrument that measures minute variations in color in the wine. The winemaker can follow a wine's progress if she uses it over a period of time to check for browning, which would mean the wine is oxidizing.

When you step out onto the rampway above the tank room you'll notice two unique characteristics. On the low-tech end colorful ribbons tied to tanks and other pieces of equipment give quick visuals on the wine that goes with them. Red ribbons designate Merlot, green, Sauvignon Blanc, and yellow, Chardonnay. If you ask why the tanks are on legs, you'll learn it's so "they can dance like ballerinas" when an earthquake hits. On the Wall of Knowledge a three-dimensional topographic map shows the path that the Rodgers Creek fault takes through this valley.

As you pass the Wall of Knowledge again, you'll be introduced to the wine that has had more care than maybe any in the entire world. The limited bottling of two hundred cases and expensive price mean you'll have to buy one to taste, unless it's already sold out. This Chardonnay, named Journey, started out as seven hundred barrels of Sonoma Chardonnay. Over three years and using their scientifically measured approach, the winemakers eventually culled the

top nine barrels to make a very oaky, complex wine that critics have held up to its French counterpart, white Burgundy.

Back in the tasting room, a sunbeam from the round window above spotlights the lavender-colored carpet, a warm reminder of the gardens. Here, while sampling current releases of Sauvignon Blanc, Chardonnay, and Merlot, if you're curious about the winery's name, the story is worth requesting. In brief, a band of local Pomo Indians used to dress their deer in the creek that flows through the valley. When the Spanish came, they adapted their graphic word *matanza*, which means slaughter, as the creek's name. There's a glint in the guide's eye before he finishes the story with a question: "Does this mean Matanzas Creek wine is to die for?" 🦌

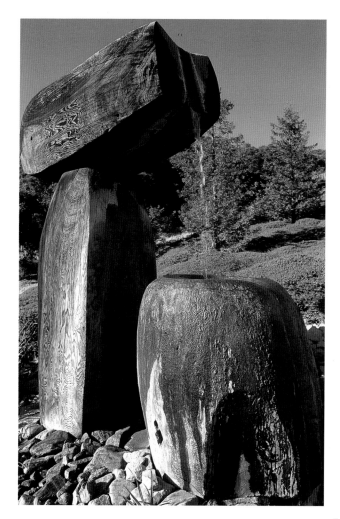

RAVENSWOOD WINERY

18701 Gehricke Road
Sonoma, CA 95476
(707) 938-1960
fax (707) 938-9459

Winemaker: Joel Peterson

Winery owners: Joel Peterson and
W. Reed Foster, et al.

ACCESS

Location: About 1½ miles northeast of
Sonoma. From the Plaza take East
Napa Street or East Spain Street and
turn left on Fourth Street East. Turn
right on Lovall Valley Road and left
on Gehricke Road; bear right at the
fork and follow the signs to the park-
ing lot.

Hours open for visits and tastings:
Daily 10:00 A.M.-4:30 P.M., except
New Year's Day, Thanksgiving, and
Christmas.

Appointment necessary for tour? Yes.

Wheelchairs accommodated? Yes.

TASTINGS

Charge for tasting? No.

Typical wines offered: Chardonnay;
Cabernet Sauvignon, Merlot,
Zinfandel.

Sales of wine-related items? Yes,
including books, shirts, posters.

PICNICS AND PROGRAMS

Picnic area open to the public? Yes.

Special events or wine-related pro-
grams? Barbecue in the Vineyards
produces authentic southern-style bar-
becued chicken and ribs on weekends
from May through Labor Day. Signing
up for the mailing list secures equal
opportunity in the random name
drawing for buyers of the special lots.

EN-ROUTE FOOD AND FARMS

Gehricke Ranch: walnuts. Open by
appointment. At 19190 Gehricke
Road, Sonoma; (707) 938-8312.

Also see Buena Vista, Sebastiani, and
Gundlach-Bundschu.

FEW WINERIES IN THE WORLD APPROACH MECCA STATUS among their devotees. Ravenswood has that appeal to lovers of Zinfandel. In the charming little hillside tasting room outside of Sonoma, you'll meet people who've come from all over the country. Some are on a pilgrimage to taste their favorite Zin at the source. Some are on the grand winery tour. And others have come specifically to see if being here in person will raise their chances of getting a few more bottles from the limited allocations of their favorite vineyard designation.

The mystique of this peppery, berry, and sometimes rough-flavored dark red wine begins with the origins of the grape itself. Authorities place it as a relative if not a descendant of Primitivo, a southern Italian grape. Alternatively they say it is really *zeinfindall*, a Hungarian grape. For practical purposes, however, Zinfandel, grown in the state for over 130 years, is California's wine grape.

For the winery tour, you'll meet your guide in the tasting room and head outside to the crush pad. Ravenswood's history begins in 1976, when winemaker and co-owner Joel Peterson contracted for a batch of Zinfandel grapes and rented a space to make them into wine at Joseph Swan's winery in the Russian River area. The recounting of his first experience, which produced 300 cases of Zinfandel, is also the story of the winery's name and the significance of the ravens.

As harvest time was nearing and rain was threatening, Joel had to decide whether to hold off and wait for a little more ripeness and chance the rain or to pick right away. Finally, he made the decision to pick. In the late afternoon, with menacing clouds looming overhead, Joel arrived at the vineyard to find that all the grapes were picked and neatly stacked in bins at the ends of the rows and the crew had gone home.

Alone, Joel raced against the rain and loaded every bin onto the truck. As he worked in waning light, three noisy ravens watched from the bleak silhouette of a tree. Several hours later he had the grapes fermenting in open-top barrels. While Joel considered the ravens, he remembered the scene from the opera "Lucia di Lammermoor" where Lord Ravenswood sinks to his death in quicksand—exactly how a new winemaker might feel upon entering the business. Ravenswood was named. The illustration for the label was designed by David Goines, a celebrated San Francisco Bay Area artist.

Over the next fifteen years, Ravenswood wines were made in a shed on the edge of the Sangiacomo Ranch near Carneros. In 1991, when the winery here on Gehricke Road became available, Ravenswood moved in. With the property came eighteen acres of vineyards. Three acres of Merlot are the block you see adjacent to the parking lot. Fifteen acres of Chardonnay on the hillside determined that Joel would apply his particular style to that grape as well. Thus the motto "No Wimpy Wines" applies to all fifty thousand cases of Ravenswood wines.

As you go through the winemaking process the guide reiterates that the focus is on letting the wine develop as naturally as possible. "Just the way it was done a hundred years ago," he

RAVENS

WOOD

ZINFANDEL
SONOMA COUNTY
1 9 9 2
MADE AND BOTTLED BY
R A V E N S W O O D
SONOMA, CALIFORNIA
CONTAINS SULFITES
ALCOHOL 14.5% BY VOL.

says, while adding that if they need modern technology they are glad it is available.

Moving to the fermentation room, you'll see the open-top redwood fermenters that look like hot tubs. Here the red wines spend ten to twelve days fermenting in their own wild yeasts. Three to four times a day, the cap of skins that has floated to the top is punched down. When fermentation ceases and the skins sink to the bottom, the wine is left a couple of weeks longer with the skins. This process of extended maceration is a typical Bordeaux technique to extract as much of the flavor and color from the skins as possible.

The most fun of the tour is a trek into the barrel room to sample the recent vintages by vineyard. For some visitors this experience is like receiving a sacrament. As the guide climbs to a selected barrel, he dips in the "wine thief" he's been carrying, extracts a tubeful, and releases some into the glass you've been toting through the tour. Four wines, including the coveted Zinfandel from Old Hill and Dickerson vineyards, are tasted for comparison.

This preview of vintages yet to be released titillates the Zinfandel devotees on the tour. As we return to the tasting room, they eagerly sign up on the mailing list, which gives equal opportunity for wine purchases by a random lottery. The conversation at the tasting bar builds up to a glass-raising bravado and a self-congratulatory toast of allegiance to the gutsy approach that has indeed kept wimpiness out of Ravenswood wines. 🐦

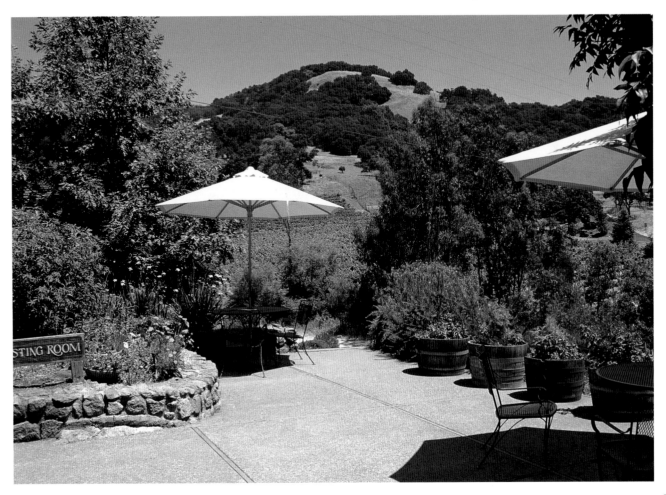

SEBASTIANI VINEYARDS

389 Fourth Street
(P.O. Box AA)
Sonoma, CA 95476
(707) 938-5532
fax (707) 996-3349

Winemakers: Mary Sullivan
and Mark Lyon

Winery owner: Sylvia Sebastiani

ACCESS

Location: In the town of Sonoma. From East Spain Street on the north side of the Plaza, proceed three blocks east and turn left on 4th Street. Tasting room and parking lot are on the right.

Hours open for visits and tastings: Daily 10:00 A.M.-5:00 P.M. Guided tours 10:15 A.M.-4:20 P.M. daily, except New Year's Day, Easter, Thanksgiving, and Christmas.

Appointment necessary for tour? No.

Wheelchairs accommodated? Yes.

TASTINGS

Charge for tasting? No.

Typical wines offered: Chardonnay; Barbera, Cabernet Franc, Cabernet Sauvignon, Merlot, Mourvèdre, Syrah, Zinfandel.

Sales of wine-related items? Yes, including logo glasses, *Mangiamo, Let's Eat,* by Sylvia Sebastiani, aprons, condiments, and more.

PICNICS AND PROGRAMS

Picnic area open to the public? Yes.

Special events or wine-related programs? Vintage Festival in September.

EN-ROUTE FOOD AND FARMS

Vella Cheese Company: cheddars, other cheeses also made here, and butter. Open Monday-Saturday 9:00 A.M.-6:00 P.M., Sunday 10:00 A.M.-5:00 P.M. At 315 Second Street East, Sonoma; (707) 938-3232. Mail order, too.

ESTABLISHED IN 1904, SEBASTIANI IS ONLY TWO BLOCKS away from the most northern California mission, San Francisco Solano de Sonoma. The mission vineyards, first planted in 1824, now belong to Sebastiani. You can see them just west of the parking lot next to Sebastiani's binning cellar.

The seven flags that have been raised over the region flutter in front of the original stone cellar, now the tasting room. They represent England, Imperial Russia, Spain, Mexico, the Bear Flag Revolt, California, and the United States. A state of California historical marker gives a brief chronology of the mission vineyards, first planted to make sacramental wines and later for commercial production.

Sebastiani's tour offers an elementary explanation of winemaking, one gauged, more than most tours, for families. The main reason so many people congregate outside, however, is to take the twenty-minute walk through the winery to see one of

the largest collections of hand-carved barrels in the world.

The guide leads you inside the old winery and begins with the winery's history. It was founded by Sam Sebastiani, who emigrated from Italy in 1895. In 1904, when Sam started the winery, the bulk of his wine was made for others. It wasn't until his son August (Gus) and Gus's wife Sylvia took over in 1954 that Sebastiani wines became known by their own label. Gus died in 1980 and Sylvia continues to play a major role in the winery. Their son Don, a former California State Assemblyman, is now the manager.

As the guide opens the doors into the barrel room, she turns on the light and you get the first glimpse of the carved barrel caps. All of the carvings were done by Earle Brown, a retired signmaker and friend of Gus Sebastiani. He chiseled the round caps and barrel ends for Sebastiani between 1967 and 1984. One of his final masterpieces is at the end of the tour—a portrait of himself as Bacchus.

Most of the motifs are from nature and many are grapes and wild birds. Gus was a patron of wildlife and bird preservation, and must have passed on a gene for it to son Sam, whose winery Viansa, in Carneros, includes a wetlands and bird preserve. The birds dominate in this room, where the decorative caps were placed on the sides of five-thousand-gallon upright redwood tanks.

Before stepping down from her platform, the guide begins her wine lesson. She asks, "Can you make white wine from red grapes?" and launches into a basic explanation of winemaking faster than you could swirl, sniff, and sip your first glass.

The tour proceeds with a look at the magnificent old redwood tanks, each of which holds sixty thousand gallons. If you and a string of solely designated descendants had one glass of wine every day, according to the guide, this barrel would last eight hundred years.

The last aisle of barrels features carvings of the most common grape varietals and their names—Zinfandel, Pinot Noir, Chenin Blanc, Gamay Beaujolais, Johannisberg Riesling, Barbera, Gewürztraminer. On the final wood carving on view before you leave the cellar is an appropriate welcome to the tasting room. It was the motto of the elder Sam Sebastiani:

Happy Haven Ranch: strawberries, jams, chutneys, tours (call ahead). Open April-December, Monday-Saturday 10:00 A.M.-6:00 P.M. Sunday by appointment. At 1480 Sperring Road, Sonoma; (707) 996-4260.

Also see Buena Vista, Ravenswood, and Gundlach-Bundschu.

Quando un bichiere de vino invita il secondo—il vino è buono. ("If one glass of wine invites a second, the wine is good.")

Just before you go into the tasting room, a lesson is shared on how to taste. Drink white before red, dry before sweet, and young before old. Taste four or five at the most.

After tasting be sure to wander over to see the mission vineyard. A bike path through the middle of the vines is often used by joggers and baby-buggy-pushing parents. The wine from Criolla, the mission grape, never had any great following, but Sebastiani keeps one vine growing in the old vineyard. Planted in 1986, it produces about three hundred pounds of grapes a year. You can't miss its tree-like shape and huge size. It is fast becoming one of the wine country's most popular photo settings. 🐾

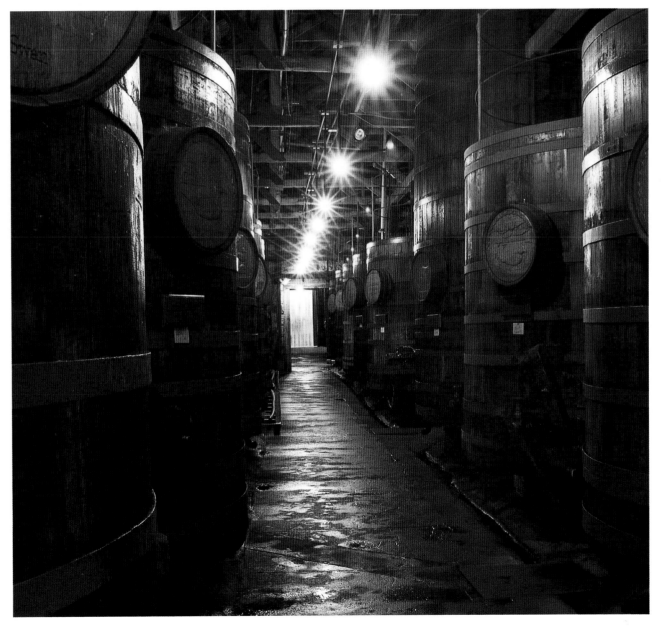

VIANSA WINERY & ITALIAN MARKETPLACE

VIANSA WINERY & ITALIAN MARKETPLACE

25200 Highway 121 (Arnold Drive)
Sonoma, CA 95476
(800) 995-4740 or (707) 935-4700
fax (707) 996-4632

Winemaker: Sam Sebastiani

Winery owners: Vicki and Sam Sebastiani

ACCESS

Location: About 6 miles south of Sonoma. From Highway 101 take Highway 37 or 116 to the east (from Highway 80 take 37 to the west). Turn onto Highway 121 and proceed about 4 miles from either direction to the entrance on the east side of the road.

Hours open for visits and tastings: Daily, May-October 10:00 A.M.-6:00 P.M., November-April 10:00 A.M.-5:00 P.M., except New Year's Day and Christmas.

Appointment necessary for tour? Not when self-guided. Guided tours and tasting for a minimum of 12, with various charges applied.

Wheelchairs accommodated? Yes.

TASTINGS

Charge for tasting? No.

Typical wines offered: Chardonnay, Muscat Canelli, Sauvignon Blanc; Barbera Blanc (blush); Cabernet Franc, Cabernet Sauvignon, Nebbiolo, Sangiovese.

Sales of wine-related items? Yes, a well-stocked deli of house-made entrees and salads plus an entire marketplace of food, dishes, books, and other gourmet items.

PICNICS AND PROGRAMS

Picnic area open to the public? Yes.

Special events or wine-related programs? April in Carneros; Holiday in Carneros in November; Group tours have food as well as wine tastings.

ALONG A VINEYARD-LINED JOG OF HIGHWAY 121 less than an hour from San Francisco, Viansa Winery & Italian Marketplace appears like an Italian villa perched on a Tuscan hilltop. Herb gardens at the entrance could be on the outskirts of Lucca. A welcoming opera or piece from Vivaldi resonates from speakers in the entry courtyard that doubles as the crush pad during harvest. This is the place for lovers of freshly made Italian antipasti and handcrafted Italian-style wines, for birdwatchers, and for anyone who appreciates attention to detail.

Italian right down to the door hinges and the frescoes, Viansa is the creation of Vicki and Sam Sebastiani. The name comes from a combination of Vicki and Sam ("vi" "an(d)" "sa(m)"), whose commitment to wine with food has produced a winery like no other. Vicki is the inspiration behind the daily menu of salads and pastas in the deli case as well as the sauces and preserves in the marketplace. Sam is a third-generation winemaker in Sonoma County. His mother and brother run Sebastiani Vineyards in the town of Sonoma. Sam specializes in blends of Italian varietals, such as Barbera, Trebbiano, Muscat Canelli, Sangiovese, Primitivo, and Nebbiolo.

Tours are self-guided, or with groups of twelve or more, a guided tour and tasting of both the wine and the food in the Italian marketplace is available by appointment. The self-guided tour begins in the marketplace, across the room from the deli case and the hand-painted fresco of a Romanesque couple. Through an arched doorway, follow the circular staircase to the right into the cool cellar. Let your eyes adjust to the dim light and don't be afraid of the Italian winemaker sitting on the barrel at the foot of the steps. He's stuffed, but

wait a minute and he'll give a short talk on the winery, unless he is being reprogrammed. In that case you'll have to save your questions for the tasting room staff upstairs.

In this room Viansa's red wines are being aged in beautifully carved oak casks. Doors on either side lead to dining rooms used for group tours and other entertainment. Straight ahead through another arched doorway is a fermentation room with no equal in the wine country. Ten five-hundred-gallon tanks lie horizontally behind a stuccoed façade. Only the ends of the tanks, looking like stainless steel kettle lids, are showing. Above the lids are colorful tiles, each with a handpainted scene related to winemaking. Another example of Viansa's attention to detail is the door hinges. Three coppery green hinges are embellished with different grape leaves. The top one is Cabernet, the middle Chardonnay, and the bottom is Sauvignon Blanc.

On the opposite side of the room ten-foot arched doors made from nineteenth-century barrels lead to the courtyard and crush pad. When a tour is arranged the guide meets you in this area. "We are not a large production winery," the guide will tell you. "In fact, we have the smallest crusher in the wine country." That's because small lots of individual varietals are made and kept separate until time to blend. In most wineries the crusher is a monolithic piece of machinery, but the one here is small enough to be stored over the fermentation tanks.

If you come during harvest, all the crush equipment and the bins of grapes will be out in the courtyard. Sit in the loggia, an Italian waiting room, for an intimate look at the hands-on processes. Taste the grapes hot from the vines and the juice straight from the press. Then adjourn to the marketplace, with marble tasting bars at either end, for a sample of the finished product.

The optimum way to taste the robust wines at Viansa is with a little bread and one of Vicki's bold antipasti outside at the picnic tables. The tables are shaded by rows of olive trees and the view up the Carneros toward Sonoma Valley is awesome. Below is the county's largest man-made wetlands and nature preserve, a project that took Sam two years to get approved. Ducks Unlimited oversees the preserve. Its members and birders from the University of California at Davis have counted over twelve thousand birds and sixty species on the property, including blue herons, mallards, egrets, Canada geese, and golden eagles. In addition the water has attracted turtles and otters.

Surrounding the knoll are experimental plantings of Nebbiolo, Sangiovese, Vernaccia, and Malvasia. In the hilltop garden with the V-shaped path artichokes, tomatoes, peppers, garlic, and herbs are grown for use in the deli or for making condiments sold in the marketplace.

You won't need a picnic basket to spend the afternoon at Viansa, but carrying along a market basket will add to the feeling of having been on a short, stimulating vacation in the Italian countryside. And it's the only winery where you can finish with a cappuccino. 🐾

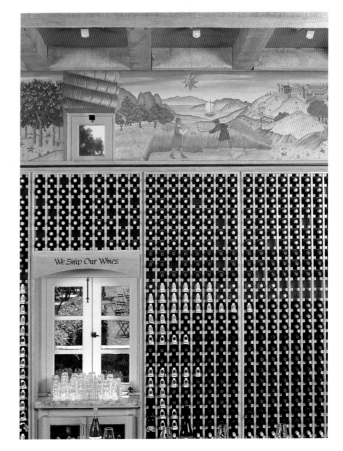

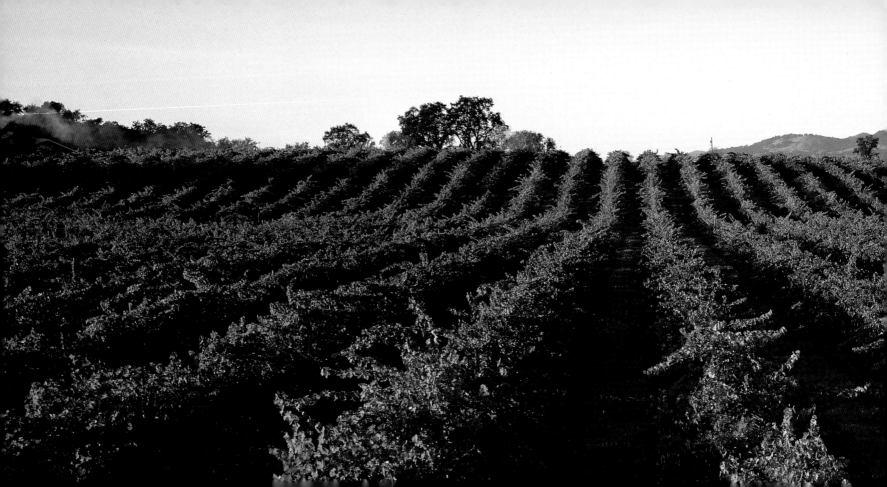

ALEXANDER VALLEY VINEYARDS

8644 Highway 128

(P.O. Box 175)

Healdsburg, CA 95448-9642

(800) 888-7209 or (707) 433-7209

fax (707) 431-2556

Winemaker: Hank Wetzel

Winery owner: Harry Wetzel family

ACCESS

Location: About 7 miles east of Healdsburg. From Highway 101 north- or southbound take the Dry Creek exit east; turn left at Healdsburg Avenue (the second stoplight), then in about 1½ miles, turn right on Alexander Valley Road. Continue (it turns into Highway 128) for about 5 miles. Winery is on the left.

Hours open for visits and tastings: Daily 10:00 A.M.-5:00 P.M., except New Year's Day, Easter, July 4, Thanksgiving, and Christmas.

Appointment necessary for tour? Yes.

Wheelchairs accommodated? Yes.

TASTINGS

Charge for tasting? No.

Typical wines offered: Chardonnay, Chenin Blanc, Gewürztraminer, Johannisberg Riesling; Cabernet Sauvignon, Merlot, Pinot Noir, and Zinfandel (Sin Zin).

Sales of wine-related items? Yes, including shirts and logo glasses.

PICNICS AND PROGRAMS

Picnic area open to the public? Yes.

Special events or wine-related programs? Winter Wineland, first weekend in January. Alexander Valley Round Robin in May. Open houses throughout the year (call for schedule). Wine Club members receive releases 8 times a year, discounts, and invitations to special events.

EN-ROUTE FOOD AND FARMS

See Field Stone, Simi, Alexander Valley Fruit & Trading Company.

THE HOMESTEAD OF ALEXANDER VALLEY'S NAMESAKE is preserved and integrated in one of Sonoma's most secure family wineries. Settled on the expanse between the Mayacamas Mountains and the Russian River, the estate has belonged to only two families since 1847. That's when Cyrus "Aleck" Alexander and his wife Rufena Lucerne received title. In 1963, the property was sold by Alexander's heirs to the Harry and Maggie Wetzel family.

The history is shared when the tour begins in the winery tasting room, which is reached by turning right from the driveway toward an umbrella of signature oaks like the one featured on the wine label.

The comfy tasting room with couches and fireplace is on the south end of the stone and redwood winery. Picnic tables on the deck provide a cool spot to stop at in the swelter of summer. Heat is not a major matter of complaint by the locals in Alexander Valley since it substantially endows the Merlot and Cabernet Sauvignon grapes with the region's acclaimed qualities.

Of the 125 acres planted on the 650 acre estate, over half are devoted to Merlot and Cabernet.

Since the land is where the story of this whole valley begins, your guide starts out with a description of the region when Cyrus Alexander scouted it for a wealthy landowner, Captain Fitch, in southern California.

For thousands of years, the peaceful Pomos lived along the valley floor, making their renowned baskets from tules and willows next to the Russian River, hunting game and gathering acorns from the abundant oak trees to process into edible meal. The influx of European settlers came on the heels of California's Gold Rush and statehood in the 1850s. By that time Cyrus Alexander had established a ranch for Captain Fitch, who secured a 48,000-acre land grant known as the Sotoyome Grant in 1841.

Upon completion of his contract with Captain Fitch, Cyrus was awarded the nine thousand acres that he chose on the eastern side of the valley. The perfect country Victorian you see from the highway is the original Alexander home. He planted wheat, apples, peaches, and grapevines and built a church and schoolhouse. He died in 1872 and Rufena died in

1908. Their graves are on the knoll above the winery. You are welcome to take the short hike up to see the gravestones. But the main attraction from the cemetery is the majestic view from this side of Alexander Valley.

The property slowly fell into disrepair after the Alexanders' deaths, and the old Victorian was boarded up when the Wetzels purchased it. The only grapes in the valley at the time were Napa Gamay, Carignane, and a little Zinfandel. In 1966, Harry Wetzel hired Dale Goode as vineyard manager. He was the first in the region to plant Chardonnay, Chenin Blanc, Riesling, and Gewürztraminer, as well as Pinot Noir and Cabernet Sauvignon. He also inaugurated the use of trellises for vine management on the North Coast. Previously all vineyards were head pruned.

By 1973, 125 acres were in full production. Two years later Hank Wetzel, just out of college, produced the first estate wines. When his sister Katie Wetzel Murphy finished at the University of California at Davis, she joined the family business as the director of sales and marketing.

The next part of the tour covers winemaking. Bucking the trend to ferment Chardonnay in barrels, Hank prefers instead to ferment it in stainless steel tanks. He leaves the Chardonnay in the tanks for two to three months without stirring to give it a slight yeasty component. Then it is aged in French oak, as is the Pinot Noir. Cabernet, Merlot, and the famous Sin Zin with the provocative label are aged in American air-dried oak barrels.

Returning to the tasting room, you can sample the eight varietals at the bar, which has a ready tray of bread cubes from Cousteaux French Bakery in Healdsburg. Katie is such a baseball fan she includes tickets to home Giants games as part of her national sales incentives to the winery's distributors and is meeting her goal to attend games in every American stadium.

Above the fireplace is a painting of the view from the Victorian's porch by Sally Wetzel, Hank and Katie's sister. The legacy of a family estate that began with the Alexanders a hundred and fifty years ago continues with the Wetzel's Alexander Valley Vineyards today. 🐾

CHATEAU SOUVERAIN

Independence Lane at Highway 101
(P.O. Box 528)
Geyserville, CA 95441
(707) 433-8281
fax (707) 433-5174

Winemaker: Thomas W. Peterson

Winery owner: Wine World Estates
/Nestlé USA

ACCESS

Location: About 7 miles north of
Healdsburg. From Highway 101 take
the Independence Lane exit; the win-
ery is on the west side of the highway

Hours open for visits and tastings:
Summer, Wednesday-Monday 10:00
A.M.-5:00 P.M., winter, Thursday-
Monday 10:00 A.M.-5:00 P.M., except
New Year's Day, Easter, Thanksgiving,
and Christmas.

Appointment necessary for tour? No
tour.

Wheelchairs accommodated? Yes.

TASTINGS

Charge for tasting? No.

Typical wines offered: Chardonnay,
Sauvignon Blanc; Cabernet Sauvignon,
Merlot, Pinot Noir, Zinfandel.

Sales of wine-related items? Yes,
including shirts, glasses, books, and
art.

PICNICS AND PROGRAMS

Picnic area open to the public? No
(restaurant on premises).

Special events or wine-related
programs? Cafe at the Winery, open
Friday, Saturday, and Sunday 12:00
noon.-3:00 P.M.and 5:30 P.M.-
8:00 P.M.

EN-ROUTE FOOD AND FARMS

See Trentadue, Jordan, and Simi.

WHEN THE SUN RISES OVER THE MAYACAMAS Mountains between Napa and Sonoma counties it casts a broad light across the Alexander Valley and shines on Chateau Souverain. You can't miss the palatial landmark reigning sovereignly (as its name implies) from the west side of Alexander Valley. The striking architecture is a blend of French elegance and Sonoma's distinctive hop kiln charm.

As you head up the sweeping driveway lined with honey locust trees, imagine yourself on the way to a French country auberge for a little lunch or supper in the vineyards. The image is stunningly close to the truth. Like the auberges of rural France, excellent food and a glorious setting intensify its allure as a destination.

Souverain's story begins in Napa County with an immigrant from Switzerland, Fulgenzio Rossini. In 1884, under the Homestead Act, he claimed 160 acres on Howell Mountain, north of St. Helena where he planted vines and established a winery. In 1943 he sold them to J. Leland Stewart, whose winemaking mentor was André Tchelistcheff. Stewart named the winery Souverain and won medals for his wines at the state fair.

From 1970 until 1986 Souverain had a string of owners and locations. The original property is now Burgess Cellars and subsequent property was sold to Rutherford Hill Winery. The Sonoma acreage, acquired in 1973, was the one to retain the Souverain name. The winery built here was designed by architect John Marsh Davis and won an AIA Design Excellence award in 1974.

Under the direction of winemaker Tom Peterson, Souverain's philosophy is to produce the varietals that best exemplify each of the county's viticultural appellations. Terroir, a French word for earth, is used by wine people to talk about the affinity between grape, soil, climate, and exposure that makes certain regions better for certain grape varietals. With its staggering range of geographic and climatic variations, Sonoma County has a spot somewhere that can grow just about any type of grape. Souverain's label may designate a viticultural appellation such as Alexander Valley or Carneros, or a vineyard, such as Sangiacomo. Or a label may

say Sonoma County which means the grapes came from vineyards in several regions in the county.

Here in the hot northern part of Alexander Valley, red grapes, especially Cabernet Sauvignon, Merlot, and the old Italian varieties, do well. The soil is loamy and gravelly and the grapes develop a black cherry flavor. The label on Souverain's Cabernet Sauvignon credits Alexander Valley. The grapes come from Souverain's estate and from neighboring Alexander Valley vineyards.

Although Chardonnay does well in some parts of Alexander Valley, it becomes famous when its home is Russian River, Carneros, or in some areas of Sonoma Valley. Souverain makes a blend of all three and designates it Sonoma County.

Dry Creek Valley is known for Zinfandel. So are other areas that have maintained old Zinfandel vineyards. Russian

River and Carneros grow laudable Pinot Noir and pockets in Alexander, Dry Creek, and Sonoma valleys tout Sauvignon Blanc as their specialty. Seeing those appellations on a label won't guarantee, but does indicate, excellence in the components.

In the tasting room you can sample the subtle differences. As you educate your palate, the nuances that the professionals identify as characteristics of each region become more noticeable. Remember, you don't have to swallow every taste. Don't feel self-conscious about learning to spit. That's how the professionals do it.

Souverain's tasting room is a colorful contrast to the sedate exterior of the winery. A mural in shades of purple and aqua, painted by artist Tony Sheets, wraps around all four walls and depicts a year in the life of a vineyard with eye-catching highlights in gold and bronze. A table set up with crayons for children encourages young artists to keep busy flexing their own creativity.

Recognizing that the best way to taste wine is with food, Chateau Souverain opened a restaurant. Open Friday, Saturday, and Sunday it's called a cafe, which the menu prices reflect. The setting, however, is purely up-market, as is the quality of the food. You can sink into upholstered chairs at linen-covered tables next to the blazing fireplace in the winter, or eat al fresco on the terrace in summer. Either way, the panorama across Alexander Valley is exquisite. If you dine at day's end, you'll see the last of the sun's rays catching the top of the chateau's roof turrets before night's shadow envelops them. 🐾

DRY CREEK VINEYARD

3770 Lambert Bridge Road
Healdsburg, CA 95448
(707) 433-1000
fax (707) 433-5329

Winemaker: Larry Levin

Winery owner: David Stare

ACCESS

Location: About 4½ miles west of Healdsburg. From Highway 101 take the Dry Creek Road exit; follow it west 3½ miles, and turn right on Lambert Bridge Road. Winery is on the left.

Hours open for visits and tastings: Daily 10:30 A.M.-4:30 P.M., except New Year's Eve and Day, Easter, July 4, Thanksgiving, and Christmas Eve and Day.

Appointment necessary for tour? No tour.

Wheelchairs accommodated? Yes.

TASTINGS

Charge for tasting? No.

Typical wines offered: Chardonnay, Fumé Blanc, Dry Chenin Blanc; Cabernet Sauvignon, Meritage, Merlot, Zinfandel.

Sales of wine-related items? Yes, including glasses, shirts, books, and jewelry.

PICNICS AND PROGRAMS

Picnic area open to the public? Yes.

Special events or wine-related programs? Winter Wineland, first weekend in February. Russian River Wine Road Barrel Tasting, first weekend in March. Passport to Dry Creek Valley, April. Open house in June. Vintner's Select Club members receive four wine shipments annually, invitations to special tastings and dinners, and extra wine discounts.

THE INFORMATION ON THE CHALKBOARD IS UPDATED every few days. You'll find out the Chardonnay is being blended that day and the Fumé Blanc is in stainless before going into barrels. Another day, twelve thousand cases of Chenin Blanc are being bottled; the 1993 reds are being racked ("clear juice transfer"); and the 1992 reds are being blended.

The staff members like to use the reports as an introduction to the goings on at this busy Dry Creek Valley winery, which produces a hundred thousand cases a year. They'll tell you it takes four clusters of grapes to make one bottle of wine. A one-acre vineyard here yields four to six tons of grapes; one ton equals 180 gallons, which equals three barrels or sixty-five cases.

As one of the United States' leading producers of Sauvignon Blanc, known here as Fumé Blanc, Dry Creek Vineyard was also the first Sonoma County winery to concentrate on it as a varietal. How that came about coincides with the founding of the winery, the first new winery established since Prohibition in Dry Creek Valley.

The founder is David Stare, a graduate of MIT and Northwestern University and an accomplished industrial engineer. When he moved from Baltimore to California in 1971 he brought an infatuation with Pouilly Fumé and Sancerre, the white wines of the Loire Valley. He also brought a vow to learn how to make them, enrolling in the enology and viticulture department at the University of California at Davis. A year later he produced his first vintage, 1,300 cases of Fumé Blanc, Chardonnay, and Dry Chenin Blanc. By 1973 he had bonded his winery in the heart of the Dry Creek Valley.

At the time only three other wineries, mostly producers of bulk wines, were in Dry Creek Valley. Today there are over twenty. David was instrumental in getting Dry Creek status as an appellation and was the first to put Dry Creek Valley on his label. Dry Creek is also the only label to have a sailboat as a logo.

Why the sailboat? David's passion is sailing. He keeps a Pearson 365 docked in Sausalito where when time permits he indulges in the sport on the windy Bay. From the irony of a boat on a dry creek (which the nearby northern tributary of the Russian River isn't) comes customer recognition.

Throughout the years, the winery has commissioned watercolor paintings with the sailboat theme as labels for reserve wines

Of the six varietals, Fumé Blanc has a particularly loyal following. Sauvignon Blanc is often described by critics as "grassy." Some vintners try to minimize that characteristic, but not Dry Creek. "Grassiness is not a negative word to us," you'll be told. In fact, that very quality coupled with the complex depth that the grape develops is what aroused David's love of the wines in the Loire. He describes the flavor of his wine as "straightforward sass with a crisp finish." Encouraged by the wine's popularity, David helped organize the Society of Blancs (SOBs). Since the wine is inspired by the French, Dry Creek actually uses a variation of its French name, *Blanc Fumé*. "Fumé Blanc" was first used by Robert Mondavi to designate a dry Sauvignon Blanc.

As red wines gain favor, Dry Creek is increasing production of Merlot and Zinfandel. Both of these plus the Cabernet Sauvignon and the Meritage—a Bordeaux-style-blend—are made entirely from Sonoma County grapes.

Dry Creek Vineyard is an all-season winery for visiting. The tasting room is a warm harbor with a huge stone fireplace aglow during winter deluges. In the spring wildflowers are planted as cover crops between the budding vines. At harvest you have a clear view of the crushing and juicing which take place between the parking lot and the winery. And when the madness of crush is over the valley floor surrounding the winery is a multicolored paisley carpet in seasonal transition.

One spring day in the tasting room, a suntanned man with a straw hat came in with an armload of the gigantic orange, yellow, pink, and red tulips he raises and trucks into San Francisco to sell at the flower mart. He brought them in exchange for the pomace he had hauled from the winery after crush. If you aren't familiar with pomace, the staff is quick with the information. It is the stems, seeds, and skins left over from pressing the grapes, and a perfect garden mulch.

In addition to dispensing information in the tasting room, the winery with its country French architecture, always-blooming flower garden, and intimate scale is one of the favorite picnic sites in Sonoma County.

EN-ROUTE FOOD AND FARMS

Dry Creek General Store: deli with picnic provisions, sodas, and selection of Sonoma food items. Open Sunday-Thursday 7:00 A.M.-7:00 P.M., Friday & Saturday, 7:00 A.M.-9:00 P.M. At 3495 Dry Creek Road (at Lambert Bridge), Healdsburg; (707) 433-4171.

Timber Crest Farms: SONOMA brand products, large selection of dried fruits and nuts. Open Monday-Friday, 8:00 A.M.-5:00 P.M., Saturday 10:00 A.M.-4:00 P.M. At 4791 Dry Creek Road, Healdsburg; (707) 433-8251; Mail order.

Bivero de Plantas / Hoskins' Ranch and Nursery: chiles, tomatoes, and flowers. Open Daily 10:00 A.M.-6:00 A.M. At 1501 Kinley Drive (off Dry Creek Road), Healdsburg; (707) 433-5562 or 431-2224.

Also see Simi, Rodney Strong, and Ferrari-Carano.

FERRARI-CARANO VINEYARDS AND WINERY

FERRARI-CARANO VINEYARDS AND WINERY

8761 Dry Creek Road
(P.O. Box 1549)
Healdsburg, CA 95448
(707) 433-6700
fax (707) 431-1742

Winemaker: George Bursick

Winery owners: Rhonda and
Don Carano

ACCESS

Location: About 9 miles northwest of
Healdsburg. From Highway 101 take
the Dry Creek Road exit, turn west,
and continue for 9 miles. Winery is on
the left.

Hours open for visits and tastings:
Daily 10:00 A.M.-5:00 P.M., except
New Year's Day, Easter, Thanksgiving,
and Christmas.

Appointment necessary for tour? Yes,
with a guide; self-guided tours of cel-
lar and garden always available.

Wheelchairs accommodated? Yes.

TASTINGS

Charge for tasting? Yes: $2.50,
applied to purchase.

Typical wines offered: Chardonnay,
Eldorado Gold (a blend of late-harvest
Sauvignon Blanc and Semillon), Fumé
Blanc; Cabernet Sauvignon, Merlot,
Sangiovese, Zinfandel.

Sales of wine-related items? Extensive
selection of packaged foods and pre-
serves, clothes including vests and ties,
gardening tools and art, and more.

PICNICS AND PROGRAMS

Picnic area open to the public? No.

Special events or wine-related pro-
grams? Winter Wineland, first week-
end in January. Russian River Wine
Road Barrel Tasting, first weekend
in March.

Passport to Dry Creek in April. Call
for schedule of other educational and
culinary events.

FIVE THOUSAND RED AND YELLOW TULIPS ARE A DRAW in the spring. Afterward, the rhododendrons bloom. Hundreds of roses flower in summer and fall. Pansies, ranunculus, petunias, and marigolds alternate as colorful borders around the winery pathways throughout the year.

You might be content to come to Ferrari-Carano to see the acres of theme gardens. Equally spectacular is tasting the wine in the villa of the century, a focal point of irresistible appeal in this northern stretch of Dry Creek Valley. Named Villa Fiore, which means "house of flowers," the building, designed by owners Don and Rhonda Carano, commemorates their Italian heritage and a shared love of good wine, food, and friends.

Before entering the showplace tasting room, pause on the terrace at the entrance. The entire picture—vineyards, foothills, winery, and gardens—contributes to a feeling that you have just arrived at a villa outside of Florence. Under the terrace one of the most beautiful barrel cellars in the world is kept cool by the gardens and sloping berm.

Inside the tasting room, known as the Wine Shop, the Italian theme is elaborated in a shopper's paradise of wine, food products, clothes, and even garden tools. Birds-eye maple trim and cabinets, faux-marbled walls, and the marbleized and etched floor are a permanent exhibition of the local artisans who specialize in antique reproduction and spent weeks on the project. Look closely at the details and stand back to see the effect.

Chardonnay is the wine that brought recognition to Ferrari-Carano. Its first 1985 vintage was awarded a ninety-four rating out of a hundred by the *Wine Spectator* and subsequent vintages have continued to be rated in the nineties. Winemaker George Bursick credits the grapes and his pick from a variety of vineyard lots for the success. Sometimes sixty different lots of Chardonnay are included in one year's blend.

In addition to the five acres of vines surrounding the villa and winery, the Caranos own six hundred acres on eleven sites in Dry Creek and Alexander Valleys, Knight's Valley, which is also in Sonoma County, and in the Carneros all the way to the Napa County border. Terrains include hillside,

bench land, and valley floor and a variety of grapes is grown on each, which is why so many different lots are available for the Chardonnay, as well as for the Fumé Blanc, Merlot, Cabernet Sauvignon, and Zinfandel.

A tour with a guide is by appointment and takes you on a complete circuit of the grounds and the winery. On the walk around the buildings you'll see a fruit orchard interspersed with olive trees, irises, and roses. Just before the crush pad is the family and employee entertainment area, with a formal bocce ball court, nine-hole putting green, and the rotisserie-barbecue built by Don Carano.

At the crush pad a must chiller drops the temperature of white grapes to 30 degrees F. in two minutes. Nearby, a horizontal rotary fermenter holds twelve to twenty tons of red grapes and operates by gently rotating the grapes inside the drum to release the juice. The intensely flavored fruit grown on the Caranos' mountain vineyards is rotated twice a day, while the lighter-flavored valley grapes are rotated every thirty minutes to extract as much flavor as desired.

Moving inside to the fermentation room, where brushed stainless steel tanks gleam, you don't see the dimpled glycol-

filled jackets that typically encircle fermentation tanks for temperature control. Here the jackets have been put on the backs of the tanks, where they have been found to be more efficient. As the guide explains, "the hot chases the cold, causing actual movement of the wine inside. We discovered these tanks to be 40 percent more energy efficient than those with the bands around them."

After the cold of the stainless-tank-filled rooms, entering the barrel cellar feels as warm as it looks. The cream-colored double-vaulted ceiling glows from lighting recessed in the pillars. From an elevated veranda with a brass railing you look out over eleven hundred French oak barrels, stacked two and three high. The center of each, which holds red wine for up

to three years, is carefully painted with a red wine stripe.

A view of this room is also accessible from the opposite end, which you can reach on your own down the stairs from the tasting room. On the self-guided tour, a video display and informational posters explain the winery operations.

Hand-painted wall frescoes on the lower level and in the ceiling dome in the main lobby of the building depict the Italian winemaking legacy and the Caranos' heritage. From the winery and gardens and such vineyard names as Dell'Oro, La Strada, and Allegro to the Marco Sassone painting on the label of the reserve Cabernet blend, the ambience at Ferrari-Carano is unmistakably Italian. 🪶

EN-ROUTE FOOD AND FARMS

Dry Creek Peach and Produce: peaches, apricots, cherries, apples, plums, melons, strawberries, corn, asparagus, tomatoes, and more. Open June-September, Tuesday-Sunday 11:00 A.M.-6:00 P.M. Phone orders other times. At 2179 Yoakim Bridge Road, Healdsburg; (707) 433-7016.

Anderson Acres: Kiwi-apple juice, chutney, barbecue sauce, jam; fresh kiwi fruit available November-April. Open daily 9:00 A.M.-dusk. At 1650 Lytton Springs Road, Healdsburg; (707) 433-3833.

Also see Dry Creek and J. Fritz.

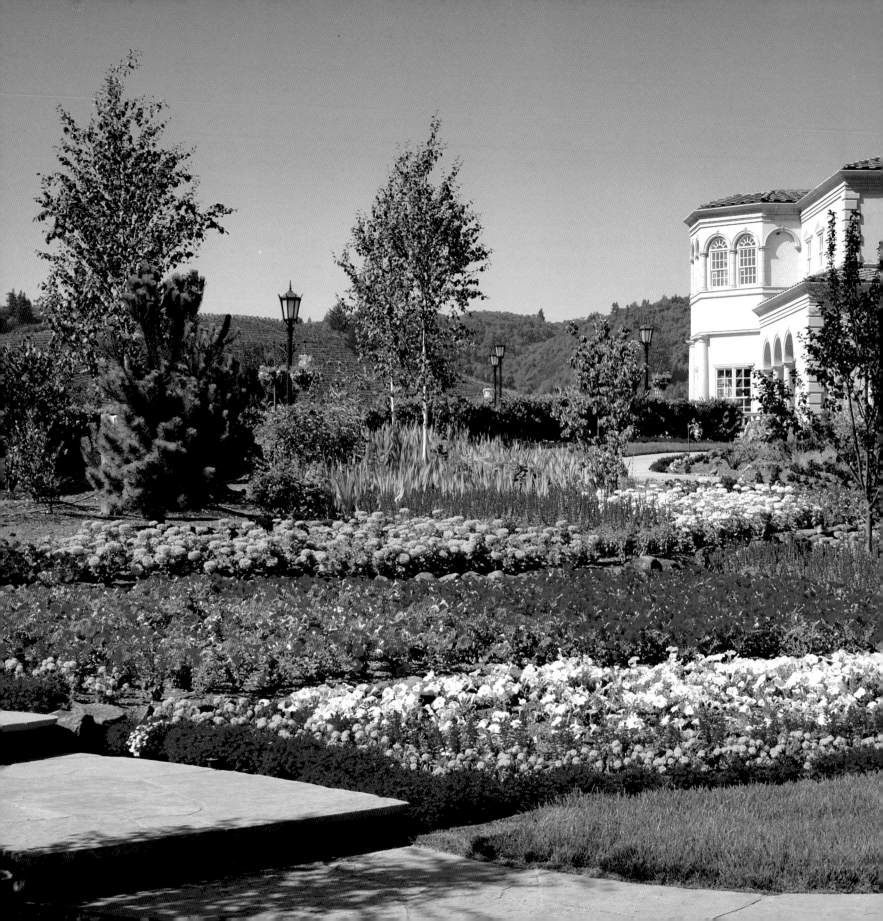

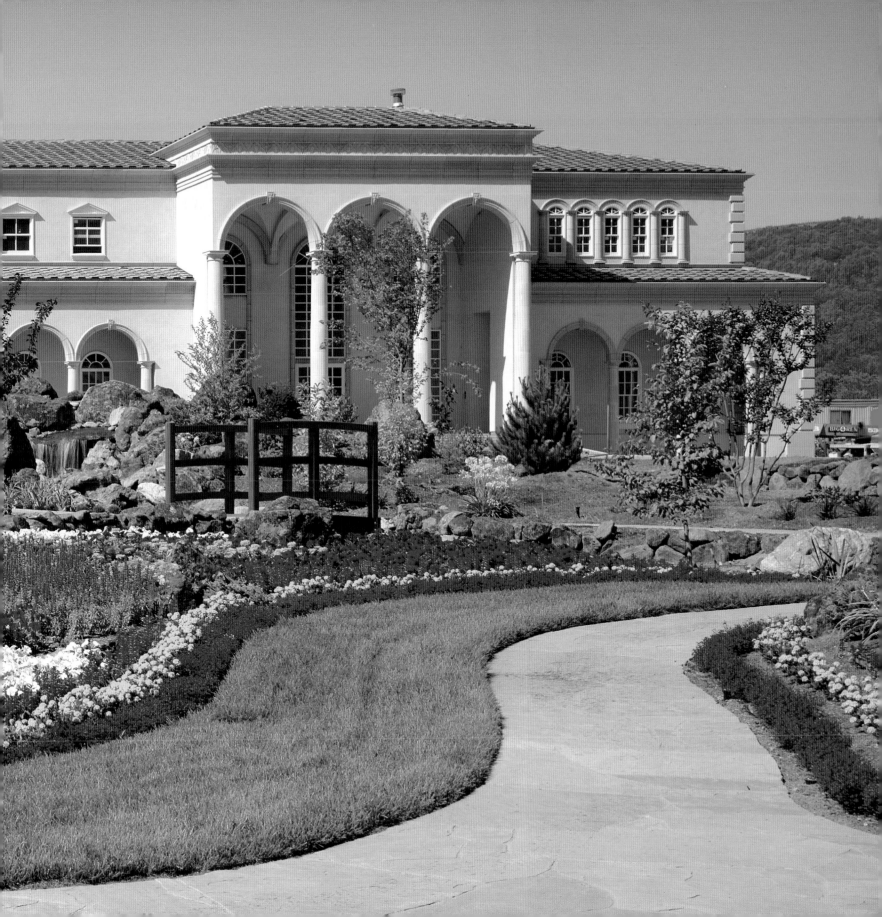

FIELD STONE WINERY & VINEYARD

FIELD STONE WINERY & VINEYARD

10075 Highway 128
Healdsburg, CA 95448
(707) 433-7266
fax (707) 433-2231

Winemaker: Michael Duffy

Winery owners: Katrina and John Staten

ACCESS

Location: About 7 miles east of Healdsburg. From Highway 101 north- or southbound take the Dry Creek Road exit east. Turn left at Healdsburg Avenue (the second stop-light), and in about 1½ miles turn right on Alexander Valley Road. Continue (it turns into Highway 128) for about 6 miles. Winery is on the right.

Hours open for visits and tastings: Daily 10:00 A.M.-5:00 P.M., except New Year's, Thanksgiving, and Christmas.

Appointment necessary for tour? Yes.

Wheelchairs accommodated? Yes.

TASTINGS

Charge for tasting? No.

Typical wines offered: Chardonnay, Gewürztraminer, Sauvignon Blanc, Viognier; Cabernet Sauvignon, Petite Sirah, and in some years a California-style vintage Port.

Sales of wine-related items? Yes, including cheese, salami, crackers, pastas, condiments, shirts, and logo glasses.

PICNICS AND PROGRAMS

Picnic area open to the public? Yes.

Special events or wine-related pro-grams? Catered Sunset Dinners once a month, June through October. Father's Day German Winefest, June. Shakespearean Evening, July. Jazz Festival, August. Harvest Blessing and Barbecue, September.

APPEARING ON THE WEST SIDE OF HIGHWAY 128 between Geyserville and Calistoga, Field Stone's small subterranean cellar, surrounded by a forest of valley oaks, is a vision of the perfect wine cellar. Selected as one of the top ten tasting rooms in Sonoma and Napa counties every year, Field Stone appeals to romantics who dream of what the classic winery should look like.

Everything is within reach in the compact setup. Inside, you walk past the bottling line and between barrels to get to the tiny redwood-paneled tasting room. Above the winery is the crush pad, with a clever gravity-flow system into the fermentation room. Nearby a horse named Shawnee, a couple of ducks, and a few chickens add to the whole inviting scene, as do the gnarly Petite Sirah grapevines planted in 1894. They supply the grapes for Field Stone's flagship wine.

You can make an appointment for an official tour or you are welcome to walk around and immerse yourself in a personal-fantasy tour of the little winery. You'll probably run into the owner, John Staten, or the winemaker, Mike Duffy, and they'll be quick to point out the hard work that goes with producing wine. But you can already tell that because John, Mike, or another staff member is attending to winemaking duties, equipment repair, or other necessary business any time you visit.

Wine is often being racked or readied for bottling. The Italian-made bottling line runs at various times throughout the year. That's because this is not a "vanilla and chocolate" winery, says tasting room host Roger. "For a small winery (ten thousand cases) we make small lots of special wines," not the expected lots of only one or two.

The varietals include a dry Gewürztraminer, Sauvignon Blanc, Chardonnay, Viognier, Zinfandel, Petite Sirah, and two Cabernet Sauvignons. In addition, there are always one or two special blends available only in the tasting room.

The winery was founded in 1977 by Wally Johnson, Staten's father-in-law. A former mayor of Berkeley, Johnson was raised on a farm in Iowa and had come to the Alexander Valley twenty years earlier to raise cattle. Over the years he planted the newer vineyards. One of his accomplishments was the invention of a mechanical upright harvester. He theorized

that to get the full fruit concentration of Chardonnay it should be picked like the corn was for dinner back home. His machine picked and crushed, and the juice was immediately piped into an airtight container right in the vineyard.

After Wally Johnson's untimely death at sixty-six in 1979, daughter Katrina and John took over the winery. A religious educator and ordained Presbyterian minister, John was a novice to winemaking, and he engaged California's legendary wine authority André Tchelistcheff as consulting enologist. The late Tchelistcheff's eleven years of advice have paid off in the excellence of the wine that John has created from the beginning.

Best known for red wines, Field Stone's Cabernet clone sources are from the who's who of vineyards. The Cabernet budwood came in 1967 from Napa Valley's prestigious Old Niebaum and Martha's Vineyards. Alexander Valley's river-bottom soil is gravelly sandy loam, which aids in high yields and intense flavor to red varietals. Coupled with the fog-tempered summer weather, the elements have helped the valley become famous for distinctive red wines.

In what is an unusual move with red wine, the Petite Sirah is blended at harvest with a white grape, Viognier. As the winemaker puts it, "this practice, borrowed from the French Côte Rôtie, allows us to overcome the undesirably harsh, grainy tannins that are often associated with this variety."

While tasting at the redwood bar in the tasting room, notice the half moon-shaped window that looks out at ground level. It's a mole's view of the picnic area that surrounds the winery. Dozens of handmade round plywood tables are set on barrels with seats perched on poles, resembling a grove of mushrooms or a scene from the Mad Hatter's tea party.

If your basket is packed with ripe cheese and crusty bread, the Petite Sirah is just the accompaniment. While checking out the wine, be sure to notice the label. The exquisitely detailed grape clusters are reproduced from photographs taken by John Staten. Field Stone is the only winery to illustrate the label with the grape that's in the wine. The thoughtful gesture only enhances the sentimental allure of this seductive winery. 🐾

En-route Food and Farms

Jimtown Store: full delicatessen, fresh breads and pastries, large stock of preserves and other Sonoma County food products. At 6706 Highway 128, Healdsburg, 95448; (707) 433-1212.

Tierra Vegetables: seasonal fruits and vegetables, chile ristras. Open by appointment. At 13684 Chalk Hill Road, Healdsburg; (707) 433-5666.

Also see Simi and Jordan.

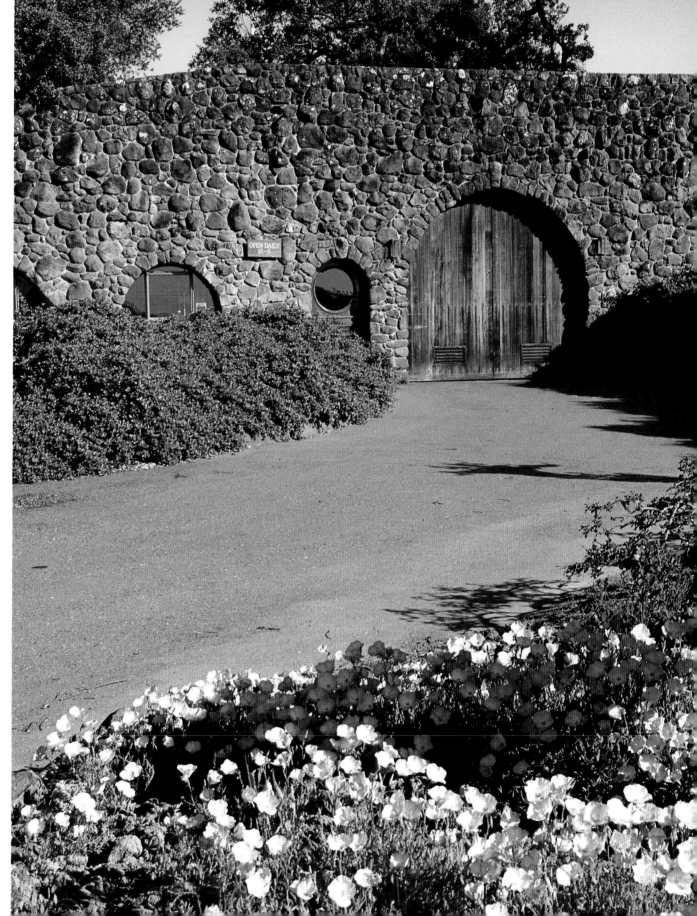

J. Fritz Winery

J. Fritz Winery

24691 Dutcher Creek Road
Cloverdale, CA 95425
(707) 894-3389
fax (707) 894-4781

Winemaker: David Hastings

Winery owner: Arthur Jay Fritz

Access

Location: About 8½ miles from Healdsburg. From Highway 101 northbound take the Dry Creek Road exit. Proceed west 9 miles and turn right on Dutcher Creek Road. Winery is in about 11 miles on the left. Watch for the sign. From Highway 101 southbound take the Dutcher Creek exit and proceed about 3 miles to the winery on the right.

Hours open for visits and tastings: Daily 10:30 A.M.-4:30 P.M., except New Year's Day, Easter, Thanksgiving, and Christmas.

Appointment necessary for tour? Yes.

Wheelchairs accommodated? Yes.

Tastings

Charge for tasting? No.

Typical wines offered: Chardonnay, Melon (de Bourgogne), Sauvignon Blanc; Merlot, Zinfandel, late-harvest Zinfandel.

Sales of wine-related items? Yes, including logo glasses, shirts, cookbooks, and gift baskets.

Picnics and Programs

Picnic area open to the public? Yes.

Special events or wine-related programs? Winter Wineland, first weekend in February. Russian River Wine Road Barrel Tasting, first weekend in March. Passport open house with music and food in April. Summer Solstice in June. Zinfandel Celebration in October.

En-route Food and Farms

See Souverain, Geyser Peak, and Ferrari-Carano.

WINERIES BECOME KNOWN FOR EXCEPTIONAL wine, unusual winemaking, quirky principles, brilliant architecture, outstanding setting, or even wily humor. J. Fritz Winery attracts attention on all of these counts.

As you wind along the far north end of Dry Creek Valley and turn onto the steep driveway, the winery appears like no other in Sonoma County. Splayed at an angle across the steep oak-studded hillside, the white stucco front looks like a cross between a Greek tabernacle and a Flash Gordon space station.

If you come in spring, my favorite season to visit, a cacophony of mating birds fills the sweet air with tweets, chirps, bleats, and warbles. Geese honk from the pond below and a chorus of crickets renders an intermittent din. A profusion of wildflowers colors the turf roof against the white façade. Everything feels deliciously alive and in motion.

Stepping up the terraced entry to the middle and only visible level of the three-tiered structure, you may sense you've seen the three arched doorways somewhere before. An abstract of them is the logo on the label. Integral to the J. Fritz

story, the arches symbolize the three essentials of grape growing: sun, soil, and rain.

Before going inside, pause on the black-tiled terrace and turn around to feast on the view, to notice the bird feeders everywhere, and also to reserve one of the picnic tables, especially if bird watching is an interest. A golden eagle, red-tailed hawk, grape-loving woodpecker, and an abundance of other resident and migratory birds have been spotted.

A cheery greeting from the open arches signals that your tour is about to begin. Inside the tasting room, a minimalist approach emphasizes simplicity and classiness. The handcrafted bar with the accordion-pleated base is made of black walnut from nearby Cloverdale. A woodstove in the corner warms the subterranean room during the cool months. But in spring through summer the arched doors are open to the terrace.

Burrowing into the hillside to build the winery was a "conservation-conscious decision" by owner and former international businessman Arthur J. Fritz to make an energy-efficient winery. Terracing the winery on three levels allows gravity flow of the wine from one production phase to the next. Using the earth for insulation is economical for temperature control.

A short hike outside and up the steep wide stairs lined with orange and yellow gazanias takes you to the crush pad. A white canvas awning shades the press and crusher. Here the Chardonnay grapes get the kind of special attention usually reserved for fine sparkling wine.

Fritz and his winemaker, David Hastings, are adamant that only "free-run" juice be used. This means the stems are removed, the grape skins broken, and the juice that runs out naturally is what they make the wine from. After that first clear fresh juice is captured, the rest of the grapes are pressed to extract a more intense liquid, which is sold off to private labels. Red grapes, like the old-vine Zinfandel Fritz is famous for, are fermented in custom-made open-top fermenters.

Hoses and pipes gravity-feed the juice to the middle level inside the winery. The theory is that the wine has less chance of being aerated by this natural flow than if it is pumped. Aeration affects the flavor and color of the grapes.

Following the hoses, inside the middle level you get a sense

of this remarkable semi-circular building built to follow the curve of the hill. From one open doorway, you can look down on the bottling line on the bottom level. There are no stairs or railing so don't step too close. Next, you pass the lab and descend the stairs to the cave, where the barrels are stacked for aging of the Zinfandel and Cabernet and fermenting of some of the Chardonnay.

Sometimes up to thirty lots of Chardonnay from various vineyard blocks are used to make one blend. Winemaker David Hastings compares blending to a Quaker meeting. "Each member's vision serves to augment all the others. The session ends when the consensus is reached."

In addition to being environmentally conscientious, sticklers for some uncommon methods, and housed in a functional and original building, J. Fritz makes award-winning top-of-the-line wines that are amazingly well priced. 🦃

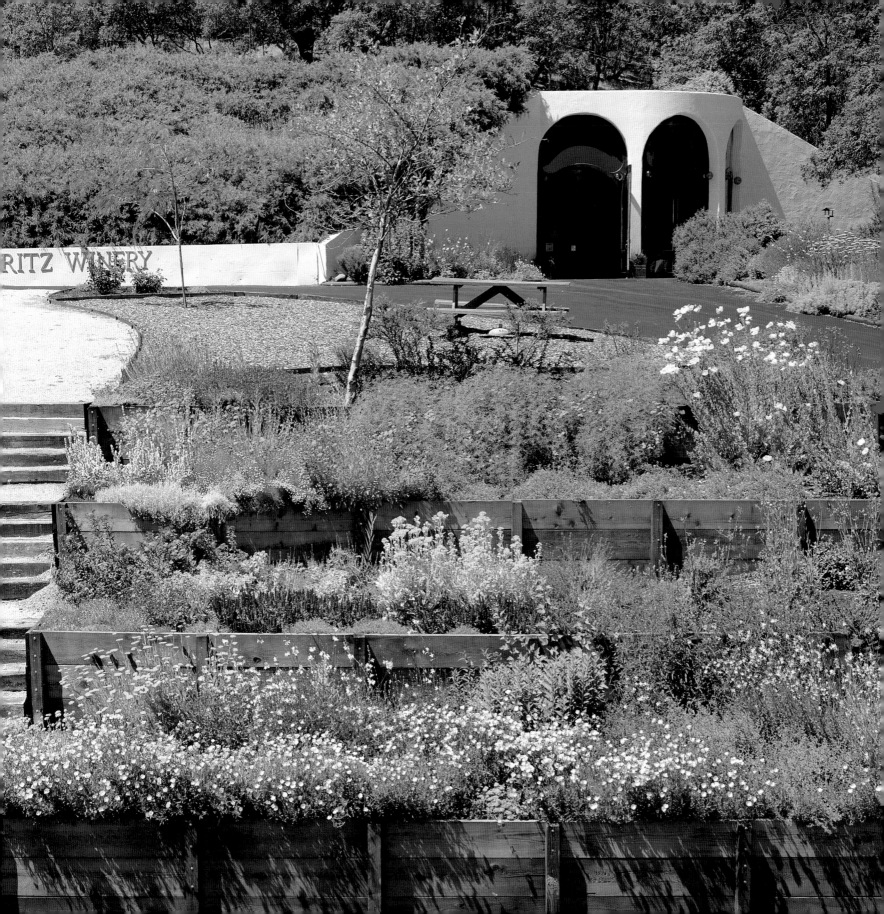

GEYSER PEAK WINERY

22281 Chianti Road
Geyserville, CA 95441
(707) 857-9463
fax (707) 857-3545

Winemakers: Daryl Groom, executive winemaker, and Mick Schroeter

Winery owner: Trione family

ACCESS

Location: In Geyserville. From Highway 101 north- or southbound take the Canyon Road exit; turn west on Canyon Road and right on Chianti. Winery is on the left.

Hours open for visits and tastings: Daily 10:00 A.M.-5:00 P.M., except New Year's Day, Easter, Thanksgiving, and Christmas.

Appointment necessary for tour? Yes.

Wheelchairs accommodated? Yes.

TASTINGS

Charge for tasting? No.

Typical wines offered: Chardonnay, Gewürztraminer, Johannisberg Riesling, Sauvignon Blanc, Semchard; Cabernet Sauvignon, Gamay Beaujolais, Meritage, Merlot, Port, Zinfandel; also tasting-room-only releases of Cabernet Franc, Malbec, Petite Verdot; and nonalcoholic grape juice.

Sales of wine-related items? Yes, including shirts, hand-painted ties, condiments and preserves, picnic baskets.

PICNICS AND PROGRAMS

Picnic area open to the public? Yes.

Special events or wine-related programs? Russian River Barrel Tasting in March. Harvest Time in October. Cellar Door Club offers wine shipments every 6 weeks, special discounts, notice of new and limited releases, invitations to semiannual luncheons, and participation in the annual crush.

A FAMILY TREE ON WINEMAKING AT GEYSER PEAK reaches out with viney tendrils to involve three continents and over a hundred and seventy years. You'd never guess the winery's wide-ranging past just by looking. The ivy-covered exterior lends an Old World security as though the winery has been here forever. The consistently high rating of the elegant wines is an accolade that often takes generations to attain.

Named for Geyser Peak, within view on the opposite side of the northern Alexander Valley, the winery was founded in 1880 by Augustus Quitzow. He constructed a 20,000-gallon facility, of which the only part left is the old building to the left of the tasting room. After seven years Quitzow sold it to Edward Walden and Company, which in 1890 made 5,400 gallons of brandy. A string of ventures, including brandy and vinegar production, sustained it until the Trione family from Santa Rosa came along.

Henry Trione, a successful investor and businessman, and sons Mark and Victor bought the winery in 1982. Shortly thereafter they sold the winery's Summit label, one of the first

bulk wines sold packaged in a box. Realizing the potential of their hundreds of acres of prime vineyards, they decided to concentrate on making premium wines. By 1989 Geyser Peak, affectionately known as "the Peak," was one of the top twenty-five wineries in California. And in 1993 Winemaker Daryl Groom was selected winemaker of the year by both *Los Angeles Times* columnist Dan Berger and wine writer Jerry Mead.

There are no tours of the winery itself, but Geyser Peak has joined Trentadue and Canyon Road (another Trione winery), neighbors on the other side of Geyserville, in hosting progressive tours offered by travel agencies. The tour begins at Trentadue with an overview of winemaking, then moves on to Canyon Road for a barbecue lunch. At Geyser Peak, a tasting of different varietals is the focus.

Whenever you are at the tasting room bar at Geyser Peak the staff is happy to lead you through a tasting. One of the specialties of the winery is the bottling of each of the five Bordeaux varietals that go into the Meritage wines. When available, you can sample Cabernet Sauvignon, Cabernet Franc, Merlot, Malbec, and Petit Verdot. The Petit Verdot and Malbec, used mainly for blending with other red wines, are rarely found bottled as varietals, which makes tasting them an experience. Afterwards, taste the blend, known as Reserve Alexandre (Meritage), and try picking out qualities that each of the Varietals contributes.

In addition to sampling the wine, Geyser Peak is a favorite picnic destination. You are encouraged to bring the whole family, sit on the arbored terrace, and enjoy the expansive view across the valley. It's always a thrill to watch the steamy geysers spout from the peaks on the horizon. Vineyards fill the valley with their colorful and textural seasonal changes next to the mighty Russian River.

Although you won't see them practicing here, the Trione men are avid polo players, and they compete all over the world. That's why Geyser Peak is the official winery of the United States Polo Association. Henry started the annual Polo, Wine and Picnic, a charity benefit, on Pater's Day in June in Santa Rosa. Firm roots in The Peak's family tree allow growth spurts in many new directions. 🦌

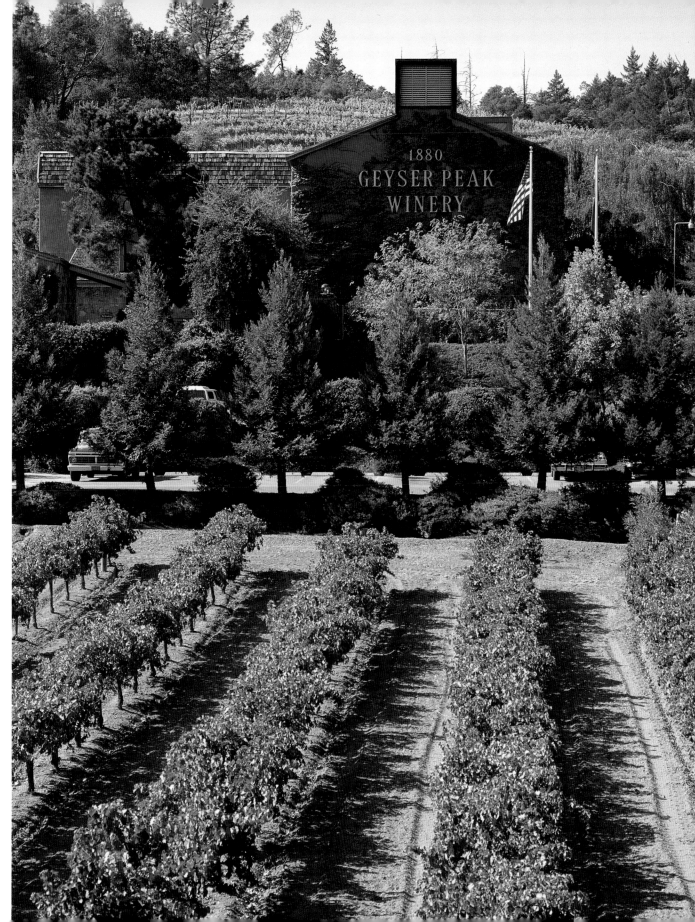

EN-ROUTE FOOD AND FARMS

Hope-Merril & Hope-Boswell Houses: spicy grape jam and wine jellies. Open daily 10:00 A.M.-2:00 P.M. At 21238 Geyserville Avenue, Geyserville, 95441; (707) 857-3356.

Also see Souverain, J. Fritz, and Trentadue.

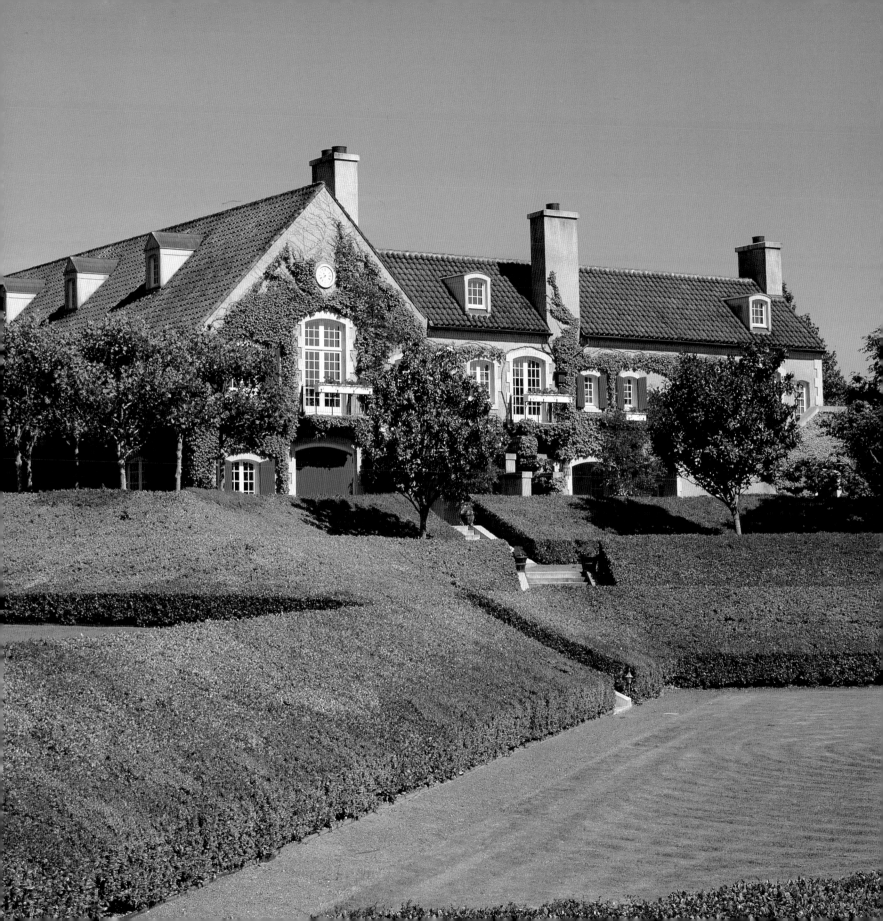

SIMI WINERY

SIMI WINERY

16275 Healdsburg Avenue
(P.O. Box 698)
Healdsburg, CA 95448
(707) 433-6981
fax (707) 433-6253

Winemaker: Roger "Nick"
Goldschmidt

Winery owner: Moët-Hennessy/Louis
Vuitton, France

ACCESS

Location: About 1 mile north of
Healdsburg. From Highway 101 north-
or southbound take the Dry Creek
Road exit, turn to the east, and turn
left at the second light onto Healdsburg
Avenue. Winery is on the left.

Hours open for visits and tastings:
Daily 10:00 A.M.- 4:30 P.M., except
New Year's Day, Easter, Thanksgiving,
and Christmas. Guided tours at 11:00
A.M., 1:00 P.M., and 3:00 P.M.

Appointment necessary for tour? No.

Wheelchairs accommodated? Yes, in
tasting room, not on tour.

TASTINGS

Charge for tasting? No.

Typical wines offered: Chardonnay,
Sauvignon Blanc; Rosé of Cabernet;
Cabernet Sauvignon.

Sales of wine-related items? Yes,
including books, shirts, logo glasses.

PICNICS AND PROGRAMS

Picnic area open to the public? Yes.

Special events or wine-related pro-
grams? Vintner's Table series of lunch-
es and dinners throughout the year.
Winter Wineland in January. Russian
River Wine Road Barrel Tasting in
March. Harvest Time in October.

EN-ROUTE FOOD AND FARMS

Cousteaux French Bakery: raisin and
other breads and deli items. Open
daily 7:00 A.M.-6:00 P.M. At 421
Healdsburg Avenue, Healdsburg;
(707) 433-1913.

THE REDWOOD TREES IN FRONT OF SIMI WINERY WERE planted by Isabelle Simi at the end of prohibition. Today they symbolize the growth, endurance, and stature of this winery that was established by two brothers in 1876, but whose continual success is due to the determination of one woman and the innovation of another.

The stories of Isabelle Simi, Zelma Long, and the winery are told during one of the best tours in the wine country. If you are particularly interested in winemaking, this is your tour. It can take over an hour depending on the group's interest and is a minicourse on the influence of the respected Zelma, who guided Simi's winemaking to its current status. The tour begins under the redwood trees.

After Giuseppe and Pietro Simi emigrated from Italy to California as young men, they started making wine in San Francisco with Sonoma grapes that were carried by wagon to Petaluma and barged across the Bay. In 1881 they decided to move closer to their source and bought an existing winery in Healdsburg. Soon, the Simis purchased this property on the north side of Healdsburg and built the stone cellar you see next to the railroad tracks. In 1904, just as the cellar was being completed, the brothers died unexpectedly.

Isabelle, the daughter of Giuseppe and the only heir, inherited the business. Only fourteen years old, she had already worked closely with her father in all aspects of the winery. Supported by an amenable staff and with her own aplomb, she took charge. Later, during the fourteen years of Prohibition, Isabelle sold off the vineyards to save the wine still in the cellar and keep the winery intact. When Prohibition ended in 1933 she was forty-three.

Two years after planting the redwoods Isabelle opened the first tasting room in California in a 25,000-gallon champagne barrel she had converted. The present tasting room, with its arched ceiling supported by barrel staves, was inspired by the original.

In 1970 Isabelle retired and sold the winery to one of her growers. It changed hands several times before 1981, when Moët-Hennessy purchased it. By then, however, the second influential woman had come on board. Zelma Long, the former head of enology at Robert Mondavi Winery, became Simi's winemaker in 1979. Now she is the chief executive officer and president of the winery, and the winemaking duties are led by Roger "Nick" Goldschmidt.

After a little hike around the old winery you come to the crush pad, where state-of-the-art equipment arrived with Zelma's management. She was one of the first in California to introduce the must chiller, an important initial stage in white-wine making.

A briefing on Chardonnay includes information on the three- to three-and-a-half-hour pressing, the race to keep oxygen out, barrel and stainless fermentation, the blending of different lots, and Chardonnay's one and a half years in the bottle before release.

Cabernet Sauvignon and other grapes for red wine are fermented with their skins in tanks with open tops. The point is

to extract tannins, which are present in the grapeskins, and which help the wine develop, just short of the point where they overpower the fruit. To promote vigorous fermentation, one of Zelma's projects was the installation of a "trickle-over" sprayer to circulate the wine over the cap of skins that rises to the top. Here, in 6,000-gallon tanks, a pipe in the middle of the tank sucks the wine up and releases it in a fine spray that trickles through the color-giving cap, letting it filter back through. The fermentation and pump-over take six to seven days.

After the examination of red-wine making, the rest of the tour is as scenic as it is informative. The top floor of the old winery building is stacked with barrels. While in the barrels, the wine is occasionally racked. This is done by inserting a hose in the middle of the barrel to remove the wine without disturbing the lees, or fruit residue, that settles to the bottom. If left in the wine the lees will leave it cloudy, making it look like a bottle of unfiltered apple juice.

A trek down the stairs brings you to more barrels and the original winery with its three-foot-thick walls. It was here that Isabelle stored the wine during Prohibition. When it was over, she had inventory ready to go, while other wineries had to restart from scratch.

Although many relics from the original winery are being replaced, the juxtaposition of old and new remains as you first see it through the redwoods across the railroad tracks. Most days, barrels are being cleaned or stored on the covered porch of the picturesque stone winery. That won't change. And neither will the long-lasting influences of two women. ✻

TRENTADUE WINERY & VINEYARDS

19170 Geyserville Avenue
Geyserville, CA 95441
(707) 433-3104
fax (707) 433-5825

Winemaker: Larry Biaggi

Winery owners: Leo and Evelyn Trentadue

ACCESS

Location: About 5 miles north of Healdsburg. From Highway 101 north- or southbound take the Independence Lane exit east, and head north on Geyserville Avenue. The winery gates with the lions are on the right.

Hours open for visits and tastings: Daily 10:00 A.M.-5:00 P.M., except New Year's Day, Easter, Thanksgiving, and Christmas.

Appointment necessary for tour? Yes.

Wheelchairs accommodated? Yes, in picnic grounds and restrooms, not tasting room.

TASTINGS

Charge for tasting? No.

Typical wines offered: Chardonnay; White Zinfandel; Carignane, Merlot, Merlot Port, Petite Sirah, Petite Sirah Port, Sangiovese, Zinfandel, Old Patch Red (blend of grapes from 100-year-old vines).

Sales of wine-related items? Yes, including picnic items, giftware, and shirts.

PICNICS AND PROGRAMS

Picnic area open to the public? Yes; also available to rent for weddings and other events.

Special events or wine-related programs? Hollyberry Fair, with arts, crafts, food, and wine, Friday, Saturday, and Sunday after Thanksgiving. Wine Country Wonderland, with arts and crafts and

I N THE HEAT OF SUMMER, THE TREE-SHADED DRIVEWAY AND the sprawling oaks and arbors around Trentadue Winery provide a cooling respite. Visiting this small winery in late August through September gives the expression "down to earth" a special meaning. With the crush pad right near the stairs to the tasting room, you can taste the grape juice as it runs from the press and compare it with the wine it will become.

Surrounded by vineyards on the floor of Alexander Valley, Trentadue Winery is one of Sonoma's most popular picnic sites. Although the beautiful lattice-covered picnic area is sometimes reserved for weddings or company picnics, the Trentadues always welcome bike-riding and other wine-tasting picnickers to their oasis in the middle of the vines. Cheese, crackers, and a variety of condiments are sold in the tasting room, or you can bring your own basket of cold cuts and bread to go with the hearty and fruit-rich Italian-style wines. Also, produce from the incredible vegetable garden, including the world's best cherries in June, is sold throughout the summer.

Leo and Evelyn Trentadue have been cultivating grapes in the middle of Alexander Valley since 1959. Leo is known as one of the pioneers in the grape business, especially when it comes to preserving the strong Italian heritage of early Sonoma grape growing in this area. When they bought the 250 acres just south of Geyserville, the property included Carignane and Merlot vines that were already over seventy years old. They added Petite Sirah, Zinfandel, and experimental lots of Aleatico, Nebbiolo, and Petite Verdot. In 1982 two acres of Sangiovese were planted. Now, nearly twenty acres are dedicated to this increasingly popular variety.

After ten years of growing grapes for other wineries, the Trentadues decided to make wine. In 1969 they converted the barn into a winery and their first releases of Chenin Blanc, Chardonnay, Carignane, and Old Patch Red (a blend of the hundred-year-old vines) were well received. Four years later they built the Italian country-style winery and tasting room.

All along Leo has been known for introducing different varietals. He was the first to make a white Zinfandel. And he was the first to release Merlot, Sangiovese, and Nebbiolo as single varietals. Until 1990 Leo and son Victor ran the winery. Then son-in-law Larry Biaggi took charge of the wine production and added new stainless fermenters and oak barrels and upgraded the bottling line. He became full-time winemaker in 1993, and production has reach 25,000 cases.

For the winery tour, a coordinated event with two other Alexander Valley wineries, you'll have to call and make reservations. The first stop is Trentadue with Larry Biaggi explaining winemaking from crush to bottling. Then you head up to Canyon Road Winery for lunch and a tour, and finish at Geyser Peak with a tasting and panoramic view of the valley. An optional visit to Lake Sonoma's fish hatchery is also offered. The emphasis can't help but have an Italian accent, since all three wineries share the heritage. Larry's talk on the old Italian grapes shines a light on the wines that are rapidly gaining American admiration.

evening bonfire, second weekend in December. Fabulous display of Christmas lights. Summer concerts (call for schedule).

EN-ROUTE FOOD AND FARMS

Hope-Merril & Hope-Boswell Houses: spicy grape jam and wine jellies. Open daily 10:00 A.M.-2:00 P.M. At 21238 Geyserville Avenue, Geyserville, 95441; (707) 857-3356.

Sangiovese is getting a lot of press lately as one of the hot new varietals. But it has been around Italy for a long time. It is the foremost grape of Tuscany and the predominant grape in Chianti. Since Sangiovese grapes tend to overcrop which weakens flavors, the vines have to be thinned twice. After fermentation, because the grape really absorbs oak, it never goes into new barrels.

Carignane, one of the old varietals that came with the property when the Trentadues purchased it, is a French grape with a name that comes from the Spanish town of Cariñena. It is often referred to by writers and winemakers as a "work horse" grape because of its ease of growing and versatility as a varietal or in a blend. Whether it was one that Agoston Haraszthy imported from Europe or it came with other vintners, hundreds of acres of it have been planted in California. It does especially well in the Alexander Valley and is becoming a popular inexpensive varietal.

To open a picnic basket under the cooling shade of the grapevine-covered arbor is to indulge in relaxation Italian-style. The surrounding vineyards, the Venus de Milo at the corner of the restrooms, the lion fountain, even the name Trentadue, which means thirty-two, are all reminders of the generations of Italians who have embraced this valley.

A toast on the wine label further commemorates the heritage and sums up the family's warmth and hospitality. It says *saluté ed auguri*, to your good health, with best wishes.

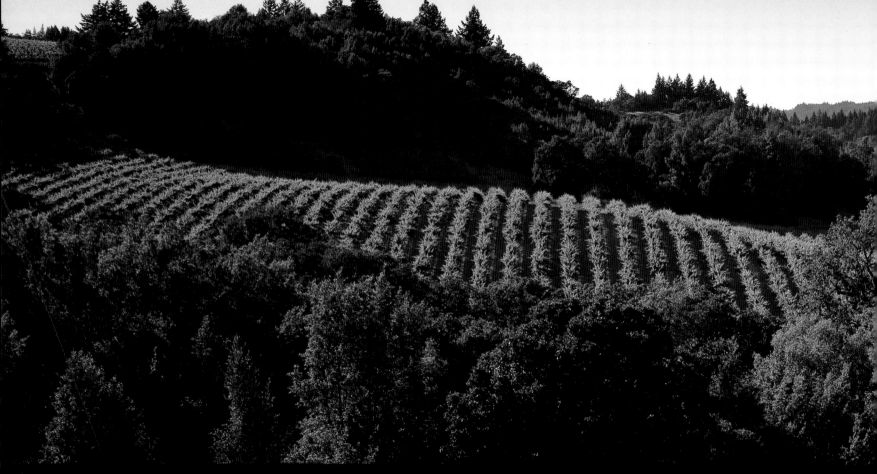

EN-ROUTE FOOD AND FARMS

Westside Farms: Vegetables, fruit, popping corn, animals, hay rides. Call for hours. At 7097 Westside Road, Healdsburg; (707) 431-1432.

Sonoma Antique Apple Nursery: 100 varieties of apples plus other fruits and nuts. Call for appointment to visit. 4395 Westside Road, Healdsburg; (707) 433-6420. Mail order, too.

Also see Armida.

Dragonfly Fa
vegetables, h
Labor Day, d
10:00 A.M.-
March, call F
Road, Heald

Also see Hop

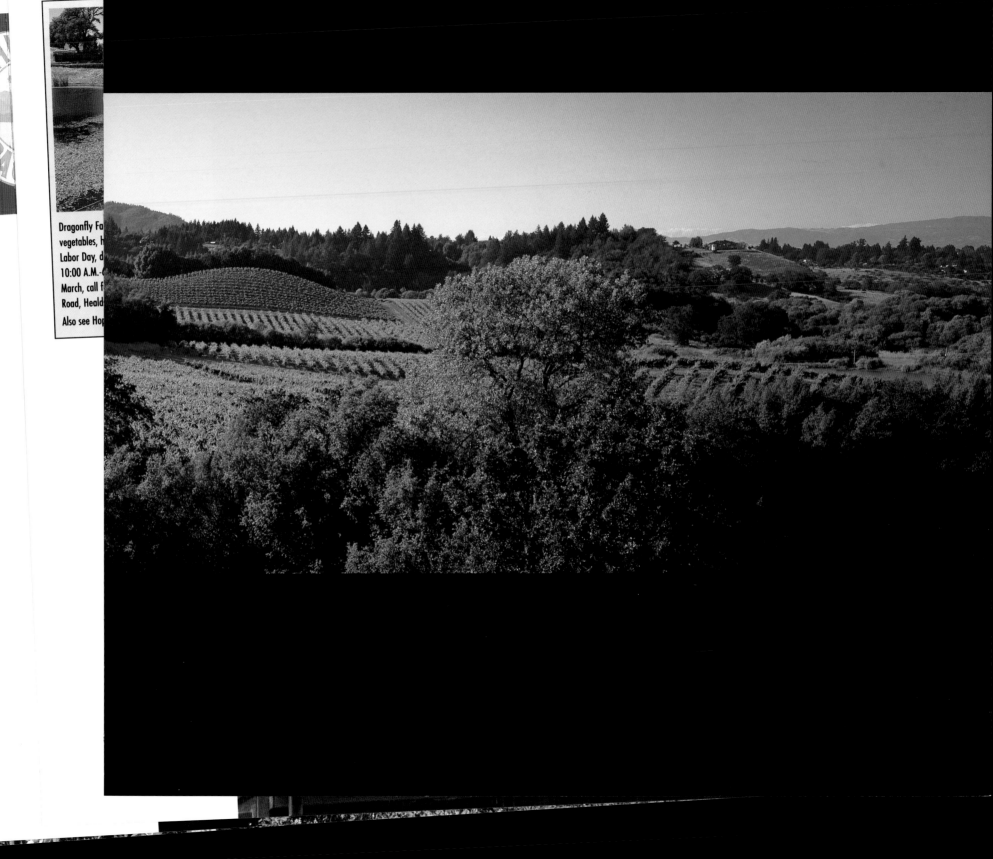

IRON HORSE VINEYARDS

ARMIDA WINE

2201 Westside R
Healdsburg, CA
(707) 433-2222
fax (707) 433-2

Winemaker: Fra

Winery owners:
Bruce Cousins,

ACCESS

Location: About
Healdsburg. Fr
northbound, ta
Healdsburg ex
turn left on We
it 3 miles to th
the right.

Hours open fa
Daily 10:00 A
New Year's D
Thanksgiving,

Appointment

Wheelchairs

TASTINGS

Charge for ta

Typical wine:
Pinot Noir, N

Sales of win

PICNICS A

Picnic area
bocce ball c

Special ever
grams? Rus
events and
events.

EN-ROUT

Middleton
vegetable:
tomatoes,
October, N
5:30 P.M.
P.M. At 2(
Healdsbu

FOPPIANO VI

12707 Old Red
(P.O. Box 606)
Healdsburg, CA
(707) 433-727
fax (707) 433-

Winemaker: Bil

Winery owner:

ACCESS

Location: About
Healdsburg. Fro
northbound, ta
Avenue exit an
south take the
exit and turn ri
½ mile, on the
sign.

Hours open for
Daily 10 A.M.-
Christmas.

Appointment n
for winery. Sel
anytime.

Wheelchairs a

TASTINGS

Charge for tas

Typical wines
Sauvignon Bla
Petite Sirah, Z

PICNICS AN

Picnic area op

Special events
grams? Russi
in September;
music and ap
Winter Winel

En-route Foo
Salami Tree D
salads; Sono
304 Center S
(707) 433-7
Also see Rod

HOP KILN WINERY

6050 Westside Road
Healdsburg, CA 95448
(707) 433-6491
fax (707) 433-8162

Winemaker: Steve Strobl

Winery owner: Martin Griffin, M.D.

ACCESS

Location: About 6 miles southwest of
Healdsburg. From Highway 101
northbound take the Healdsburg
Downtown exit; southbound take the
Westside Road exit. Head west on Mill
Street, which turns into Westside
Road. Proceed approximately 6 miles
to the winery.

Hours open for visits and tastings:
Daily 10:00 A.M.- 5:00 P.M., except
New Year's Day, Easter, Thanksgiving,
and Christmas.

Appointment necessary for tour? Yes.

Wheelchairs accommodated? No.

TASTINGS

Charge for tasting with tour? No.

Charge for tasting without tour? No,
except some reserve wines.

Typical wines offered: Chardonnay,
Gewürztraminer, Johannisberg
Riesling; White Zinfandel; Cabernet
Sauvignon, Valdiguié, Zinfandel.

Sales of wine related items? Yes,
including Sonoma cheese and crack-
ers, logo glasses, hats, aprons, shirts,
and napkins.

PICNICS AND PROGRAMS

Picnic area open to the public? Yes.

Special events or wine-related pro-
grams? Winter Wineland, first week-
end in February. Russian River Wine
Road Barrel Tasting, first weekend
in March.

IRON HORSE VINEYARDS

9786 Ross Station Road
Sebastopol, CA 95472
(707) 887-1507
fax (707) 887-1337

Winemakers: Forrest Tancer, Michael
Scholz (still), and Raphael Brisbois
(sparkling)

Winery Owners: Audrey and Barry
Sterling, Joy Sterling and Forrest
Tancer

ACCESS

Location: About 12 miles west of
Santa Rosa. From Highway 101 take
the Steele Lane/Guerneville Road
exit, and turn west; This turns into
Guerneville Road. Take it to the end,
turn right on Hwy. 116 (Gravenstein
Highway), and in about 1 mile, at
Kozlowski Farms, turn left on Ross
Station Road, continuing 1 mile to the
stone-framed gate with an iron horse
on each side.

Hours open for visits and tastings:
Saturday and Sunday 10:00 A.M.-
4:00 P.M.; weekdays by appointment.
Closed New Year's, Easter,
Thanksgiving, and Christmas.

Appointment necessary for tour? Yes.

Wheelchairs accommodated? Yes.

TASTINGS

Charge for tasting with tour? No.

Charge for tasting without tour? No.

Typical wines offered: Brut, Brut Rosé,
Blanc de Blancs, Wedding Cuvée (blanc
de noirs) sparkling wines. Chardonnay,
Fumé Blanc; Cabernet Sauvignon,
Pinot Noir (in certain years).

Sales of wine-related items? Logo flutes,
A Cultivated Year, by Joy Sterling.

PICNICS AND PROGRAMS

Picnic area open to the public? Yes.

Special events or wine-related pro-
grams? Call for schedule.

THE FIRST GLIMPSE OF IRON HORSE FROM THE FACING slope on Ross Station Road is a vision. The diamond-shaped hill is cut by emerald vines in summer and chains of coppery leaves in autumn. Winding up to the pinnacle, a sentry of palm and olive trees (yes, it's called Palmolive Way) lines the last stretch to the parking lot.

The tiny tasty room is in the farthest of the barn-red buildings at the north end of the knoll. The informality and simplicity of the buildings give the appearance of a working farm, nothing as fancy as the reputation of the owners would portend.

The view, on the other hand, is something to behold. On a clear day you can see all the way across Sonoma County to Napa's Mount St. Helena. Turn around, and in the summer the fog may be just rolling in from or creeping back to the Pacific, only twelve miles away. It is this proximity and the resultant extra coolness that established "Green Valley" as its own appellation in the Russian River region.

In good weather the tasting bar is outside. Before the tour begins, a glass of sparkling wine and a brief history of the winery are shared. The Iron Horse name comes from the train, a spur of the Petaluma-Russian River line, that used to stop at Ross Station.

Barry and Audrey Sterling purchased the property in 1976.

His occupation as an international attorney and hers as hostess and restoration expert had kept them on the go for over twenty years. The ranch offered a place to settle down and realize Barry's dream to garden, raise grapes, and make wine. The hundred-year-old Carpenter Gothic farmhouse where they live challenged Audrey's restoration skills and is now completed.

Son Laurence and his family and daughter Joy also live at the ranch. Forrest Tancer, who helped develop the initial vineyards on the property, is the winemaker and partner in Iron Horse as well as Joy's spouse. Joy is the marketing man-ager and travels frequently promoting their wines. Her book A Cultivated Life, published in 1993, chronicles one year in her family's winemaking experience.

You are apt to see any or all of these principals dashing around the winery on your visit. The champagne-master, French-bred and trained Raphael Brisbois, makes regular gre-garious visits to the tasting room, especially during the winter months when winery life is less than hectic.

For the tour, with flute in hand, it's down the hill to the riddling cellar. Here thousands of bottles, in mechanized and manual riddling racks, are turned twice a day in their final stages of secondary fermentation. Although anyone giving the tour can demonstrate hand riddling, one guide, Shirley Everly, is a pro. Faster than you could pop a cork, she'll riddle the entire demonstration rack. A good hand riddler can turn two thousand cases in a couple of hours.

Technically, it takes only two weeks for bubbles to develop in sparkling wine, but the bottles are left on the yeast from one to three years. Three reasons for the longer time are for bou-quet, which refers to wine's more yeasty aroma; for texture, since the longer on the yeast the more creamy; and for the fin-ish, that is, a perception of sweetness that comes from the fruit, not from sugar. The wine is stored in heavy plywood bins known as gyros that hold 488 bottles and are earthquake-proof.

As you head back to the winery you pass the redwood building that houses the laboratory. Above it are two presses, one for sparkling wine and one for still. Up the grassy hill you reach an arbored picnic area, Iron Horse's entertaining spot, where you are welcome to bring your own picnic and feast on

EN-ROUTE FOOD AND FARMS

Kozlowski Farms: berries, natural preserves, condiments, and more; plus picnic area & bakery. Open daily 9:00 A.M.-5:00 P.M., except major holidays; At 5566 Gravenstein Highway, Forestville; (707) 887-1587.

Green Valley Farm: fresh blueberries, ice cream, shakes, muffins in summer; preserves and gift packs for the holidays; Open daily 9:00-5:00; weekends only during summer. At 9345 Ross Station Road, Forestville; (707) 887-7496.

Foxglove Farm: apples, figs, pumpkins, organically grown green beans, corn, tomatoes, basil, squash, and more. Open July-October, 9:00 A.M.-5:00 P.M. daily, except Sunday, 1:00 A.M.-6:00 P.M.; November & December, Friday-Sunday 12:00 A.M.-5:00 P.M.; rest of year by appointment; At 5280 Gravenstein Highway, N. Sebastopol; (707) 887-2759.

Redwood Hill Farm: goat milk and cheese, farm tours. Open by appointment. At 5484 Thomas Road, Sebastopol; (707) 823-8250.

Fiesta Market: picnic supplies, selection of Sonoma condiments and preserves. Open Monday-Saturday 8:00 A.M.-9:00 P.M., Sunday 9:00 A.M.-8:00 P.M. At 550 Gravenstein Highway North, Sebastopol; (707) 823-1418.

the Sterlings' view. The hill to the northwest is topped with fifty acres of Pinot Noir grapes planted in a joint venture with the French Laurent-Perrier. The grapes will be made into a *tête de cuvée*, a top of the line sparkling wine that stays on the yeast for at least four years.

If Forrest Tancer happens by ask him about his pride, the vineyard. He'll tell you about the soil type, which is known as Gold Ridge, "a sandy soil that, so far, phylloxera doesn't like." On the 330-acre ranch, 142 are planted in grapes. The huge riparian corridor that surrounds the ranch, including 30 acres of wild blackberries and the 8 acres of fruit and vegetable gardens, illustrates the principle that avoiding a monoculture is another protection against phylloxera.

The gardens that feed the families on the ranch and the parties with many guests are the passions of Barry Sterling. Even in winter, when lettuce, leeks, and artichokes are all that grow, vegetables are always being harvested. In the summer, the big garden at the entrance is a mouthwatering showpiece with forty-two kinds of tomatoes, as many peppers and chiles, and six kinds of basil. In October a grand finale showcases hundreds of pumpkins dotting the floodplain around the bridge. Visitors are asked to come up to the winery and check in before walking around the gardens.

Returning to the tasting bar, which is backlit by the afternoon sun, the priceless view and the practical setting reflect the way the owners want you to think of their wine, "sophisticated, friendly, and easy to drink." 🐾

IN THE IVY-COVERED WINERY KORBEL HOUSES A MUSEUM OF early California winemaking. Stately among the few old-growth redwoods left by the early loggers, the imposing façade overlooks Pinot Noir and Chardonnay vineyards along a narrow bend of the Russian River, only fifteen miles from the coast.

Hourly tours attract over a hundred thousand visitors a year. They begin at the old train depot, once a stop for the Northwestern Pacific Railway that between 1876 and 1935 brought vacationers and supplies from San Francisco to Russian River hamlets. Inside the yellow clapboard depot you can view antique photos featuring the Korbel brothers, Francis, Anton, and Joseph; the winery's first champagne master, Frank Hasek; trays of fruit drying where grapes now grow, and a rare snowfall in 1890.

The tour guides are as much like docents as wine experts as they dispense their wealth of biographical, and sometimes juicy, tidbits about the winery and its proprietors. The first and most photogenic stop on the tour, a round brick tower set behind the winery, houses a thirty-three-foot vertical pot still. Its significance is the starting point for the Korbel story and that of other immigrants who came in search of the American dream.

In the mid-1800s the Korbel brothers came to California as political refugees from Bohemia, now western Czechoslovakia. Their defiance of the Hapsburgs had landed the oldest brother in prison, from which he escaped. The brandy tower, a replica of his prison turret, was built as a reminder of the political persecution that he had endured and they had left.

Stepping into the old winery through painted redwood doors you pass a collection of barrels and ancient farm equipment. A few stairs lead down to one of the original cellars, saved from a fire when a quick-thinking worker pulled the bungs out of barrels on the floor above and let out the wine.

Along one dark wall, photographs and memorabilia chronicle the family's enterprises. In 1862, when the Korbels arrived in San Francisco, they manufactured cigar boxes and ornate house trim from redwood. The redwood groves along the Russian River first attracted the Korbels to the area. After logging the property, they raised prune plums, wheat, corn, alfalfa, tobacco, and grapes. Finding grapes to be the most profitable, they started making wine in 1882.

The success of one grape they had planted, the Black Pinot, or Pinot Noir, suggested that varietal's specialty—champagne—as an option. By the mid-1890s Korbel champagne was launched, and except for the years of Prohibition, production has been continuous.

The transition from logging to grape-growing is poignantly marked with the photo of six-foot high stumps that littered the vineyards for ninety years before they were removed. The stump removal in 1962 happened when a television crew, finding the land reminiscent of French countryside, contracted to use the field to film the television series "Combat." The winery agreed, with the provision that the stumps be actually blown up.

The Farmery: organically grown vegetables and lettuces. Call for appointment. At 875 River Road, Fulton; (707) 546-3276.

Also see Sonoma-Cutrer and Iron Horse.

From tidbits thrown in with the winery history, you'll learn that the brothers didn't marry until they were in their thirties and forties when their mother sent three Czech girls to be their brides. Fifteen children came from the three couples.

After the oldest Korbel retired to Europe and the other two died, the inheritance-sharing cousins ran through the family fortune in a generation and sold the winery to Adolf Heck in 1954, seventy-two years after it was founded.

Heck incorporated his ideas for making a "California-style" champagne that showcases dry fruity flavors over the previous European yeasty style. Korbel Brut, released in 1956, is the result. It is one of the seven sparkling wines included in the over 1 million cases sold annually. After thirty years at the helm, Adolf retired. His son Gary now runs the winery.

The specifics of Korbel's winemaking are featured on the rest of the tour, first with a short film. Next a walk-through takes you past riddling, dosaging, and corking demonstrations. You'll see the automatic riddling machine that Adolf Heck invented in 1966.

Outside, summer tours continue to the rose garden that surrounds the family home, built in 1874. Over 250 varieties of roses are showcased. Also in the summer, two in-depth technical tours of the garden feature the hundreds of annuals and perennials. Otherwise the tasting room is the next stop.

It's evident that no winemaking is done in the old building. On the other side of the family home, a modern million-plus-case production facility was built in 1987. If you look to the right on your way out of the parking lot, you can catch a glimpse of today's high-tech Korbel winery, in high contrast with your visit to the archives of yesterday's. 🐾

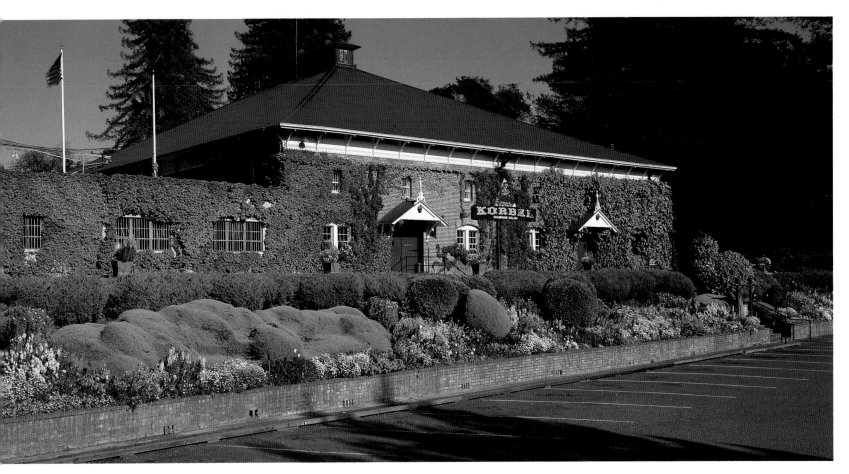

RODNEY STRONG VINEYARDS

11455 Old Redwood Highway
Healdsburg, CA 95448
(707) 431-1533
fax (707) 433-8635
Winemaker: Rick Sayre
Winery owner: Klein Family Vintners

ACCESS

Location: About 2½ miles south of Healdsburg. From Highway 101 northbound take the Healdsburg Avenue exit and turn left; heading south take the Old Redwood Highway exit and turn right. Winery is in about 1½ miles on the right and shares an entrance with Piper Sonoma.

Hours open for visits and tastings: Daily 10:00 A.M.–5:00 P.M.; tours 11:00 A.M., 1:00 P.M., and 3:00 P.M. Closed New Year's Day, Thanksgiving, and Christmas.

Appointment necessary for tour? No.
Wheelchairs accommodated? Not as of printing; call for information.

TASTINGS

Charge for tasting? No.

Typical wines offered: Chardonnay, Sauvignon Blanc; Cabernet Sauvignon, Pinot Noir, Merlot, Zinfandel.

Sales of wine-related items? Yes, including local and other specialty food products, logo glasses, shirts, books, and insulated wine carriers and backpacks.

PICNICS AND PROGRAMS

Picnic area open to the public? Yes.

Special events or wine-related programs? Art exhibits change every 6 weeks. Wine and Chocolate Fantasy before Valentine's Day. Winter Wineland, first weekend in February. Russian River Wine Road Barrel Tasting, first weekend in March. Mother's Day Picnic in May. Concerts and Shakespeare throughout the summer. Harvest Festival in October. Open

THERE'S ALWAYS SOMETHING GOING ON AT RODNEY Strong Vineyards. Three winery tours a day. Artists' exhibits and receptions. Concerts on the green. Hardly a dull moment has passed since 1959 when the winery was founded.

Everything that's taken place hasn't been entertaining, but Rodney Strong, founder and namesake, has persevered to reap his rewards. A risk taker and industry innovator, Strong hunkered down in Sonoma County with a passion for winemaking that equals his love of the area. Some of his firsts in the county include bringing in French oak barrels, designating wines by their vineyards, and finding the right locations for new plantings of varietals on thousands of acres of land. Today Rodney Strong Vineyards is making 180,000 cases a year of exemplary Sonoma County wine. When you pull into the parking lot just off Old Redwood Highway between Windsor and Healdsburg, the avante-garde pyramid and well-kept grounds allude to the prevailing success. The winery was designed by Craig Rowland, a Frank Lloyd Wright understudy.

Up the stairs and in the building you'll find the interior octagonal chamber that serves as the tasting room. If you like art galleries, before going through the second set of doors to the tasting room, pick up a brochure on the artist exhibiting and take a stroll around. Shows range from abstract stone sculptures to seascapes, works in wood to figurative ceramics.

Between the exhibits, as you circle the perimeter of the tasting room, you'll see the fermentation, storage, and barrel rooms stretched out below the railing in hundred-foot-long spokes. The winery was built with four wings in the shape of a cross as an efficiency experiment and it works. By making use of the central space under the tasting room, an enormous amount of wine is economically moved from one area of the winery to another for filtering, aging, or bottling.

Tours begin outside the northwest-facing door that overlooks the green. The wall-to-wall stairs are used as risers and a stage for summer concerts. You can bring a picnic to the green, anytime, including when a concert is scheduled.

On the other side of the green you'll see Pinot Noir vines and the east bank of the Russian River. Here the coastal cool nights and hot days are conducive to Pinot Noir. The grapes for the winery's acclaimed Cabernet Sauvignon are grown in Alexander Valley where the heat is more intense.

Just inside the winery door the guide pauses in front of an old Zinfandel vine on display. This close-up shows the size and beauty of the gnarled vine, whose shape comes from old-fashioned "head pruning." When the vines sprout new growth they resemble the head of Medusa. Grapevines aren't considered old until they are at least thirty. Then they begin to lose 10 to 12 percent of production each year. At the same time the fruit becomes more intensely flavored, which is why vintners prize the old-growth fruit.

The next stop focuses on the fermentation of white wine, which is done in ten-thousand-gallon stainless steel tanks in a temperature-controlled environment. "If left on their own, as they begin to ferment and the grapes get too hot, instead of fermenting, the yeast starts cannibalizing the natural grape sugar and causes oxidation," the guide explains. A cold controlled fermentation also helps maintain the fruit character in wine.

In the space between the wings, everyone crowds out onto a balcony overlooking the crush pad. In the winter it lies as dormant as the pruned spindles in the vineyards. At crush it's a hive of hyperactivity. Not only does Rodney Strong crush grapes for its own wine but the winery custom crushes for other wine labels, including Windsor Vineyards, the world's largest mail order winery, which shares this facility.

Back inside, your eyes will have to adjust to the darkness of the storage and barrel rooms. In the barrel cellar, hundreds of American and French oak barrels and Yugoslavian oak storage tanks are used for aging mostly red wines. A cooper is on the staff to keep the barrels conditioned. After about five years a barrel begins to lose its impact. To extend the barrel's use, the cooper shaves away the wood and retoasts it. The average barrel can take a maximum of five reshavings and toastings.

After the tour, which is as detailed as the group demands, the octagonal tasting room presents an architectural as well as energetic dimension. In contrast to the darkness of the surrounding wine wings, which are visible through windows, the tasting room is bright and the bar itself lit by a skylight. Here, if there isn't a winery affair going on, the staff may be holding its own event. A chocolate party before Valentine's Day, the release of a new wine, or a special weekend wine discount all keep this winery one of the liveliest in the county. If nothing else, Rodney Strong himself is occasionally found fingering the blues on the resident piano. 🦋

house in November. Carolers on weekends in December. Call winery for detailed schedule.

EN-ROUTE FOOD AND FARMS

Nunes Tamale Factory: housemade tamales to go or eat in restaurant. Open Monday-Saturday 11:00 A.M.-8:00 P.M. At 9910 Stare Road (sign on Old Redwood Highway just south of winery), Windsor; (707) 838-9651.

Downtown Bakery: bread, pastries, and focaccia. Open Monday-Saturday 7:00 A.M.-5:30 P.M., Sunday 7:00 A.M.-3:30 P.M. At 308 Center Street, Healdsburg; (707) 431-2719.

Also see Foppiano and Simi.

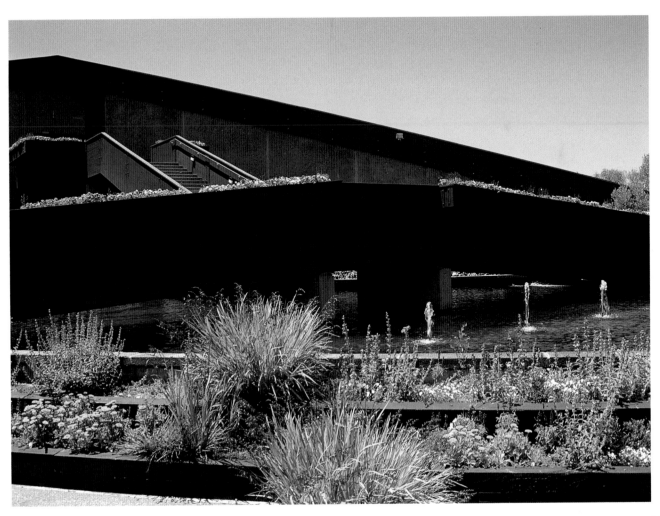

SONOMA COUNTY GRAPES AND WINES

Suggested Sonoma County food pairing.

Alicante-Bouschet: The only red grape with red juice has been popular with home winemakers and for giving color to thin wines. About 62 acres are planted in Sonoma, and it is usually blended with other grapes.

Barbera: A red hearty grape from the Piedmont region of Italy that used to be widely planted in Sonoma; now Sebastiani and a few others are the only producers. Flavor is rich and tannic rather than fruity. ❧ Angelo's (Petaluma) or Willow-side (Santa Rosa) sausages and Sonoma Mustard & Condiment Company (Sonoma) Cracked Brown Mustard.

Burgundy: A generic term for red wine in the United States, not to be confused with wine from the French region, Bourgogne. Most producers are substituting "Red Table Wine" for the old designation. Flavor can run from dry to slightly sweet. ❧ Traverso (Santa Rosa) or Salami Tree (Healdsburg) deli sandwiches.

Cabernet Franc: A popular grape for blending with Cabernet Sauvignon; over 500 acres are planted in Sonoma where the other Bordeaux varietals thrive, such as on Sonoma Mountain and in the Alexander Valley. Tastes lighter and more fruity than Cabernet. ❧ Brother Juniper's (Forestville) wild rice and onion bread.

Cabernet Sauvignon: Rich and tannic and known for its aging potential. Grows best on hot hillsides, which is where most of its 6,500 acres in Sonoma are located, including the Sonoma Mountain, Alexander Valley, Knight's Valley, and Russian River viticultural areas. ❧ Redwood Hill Farm (Sebastopol) aged goat cheese.

Carignane: Only about 300 acres remain in Sonoma of this grape that was once the most common red grape in California. It does well in warm areas such as the northern Alexander Valley. Color is dark and flavor is light. ❧ Downtown Bakery (Healdsburg) focaccia.

Chardonnay: One of the world's finest white grapes for still and sparkling wines, this is the white Burgundy from France. Over 12,000 acres are planted in Sonoma; the best viticultural areas are Los Carneros, Russian River, and Chalk Hill. Flavor ranges include oaky, buttery, intensely creamy, and fruity. ❧ Sautéed Gourmet Mushroom (Sebastopol) shiitakes, chanterelles, and morels.

Chenin Blanc: A white grape regarded for its light crispness and dry to honeylike sweetness. Grown in the Alexander Valley and Chalk Hill viticultural areas. ❧ Curried chicken with Kozlowski Farms (Forestville) Apple Chutney.

Cinsault: A red grape with deep color, this is a Rhône variety. A few acres are planted in Sonoma, where its development and use are in experimental stages.

Fumé Blanc: The name given to dry-style Sauvignon Blanc by Robert Mondavi in the 1960s, now used by many other producers of this popular wine. See Sauvignon Blanc.

Gamay Beaujolais: A light red wine grape; there are less than 200 acres planted in Sonoma of this relative of the popular Pinot Noir. Made in the Alexander Valley and Sonoma Valley viticultural areas. ❧ Bellwether Farms (Petaluma) sheep-milk cheese.

Gewürztraminer: Nearly 400 acres of this floral-scented grape are planted in Sonoma. The name comes from the German word for spice and refers to its aroma and flavor, which runs from dry (about 0.5 percent residual sugar) to quite sweet. A wonderful aperitif as well as a complement to spicy Asian food. ❧ Timber Crest Farms (Healdsburg) Sonoma Plum Duck Sauce.

Grenache: A red grape popular in the south of France and in Spain; as the popularity of Rhône wines rises, more of this grape may be seen. Often made into dry rosés with a slightly fruity aftertaste. ❧ Northwest Connection (Cotati) smoked salmon.

Johannisberg Riesling: The true name is White Riesling; about 275 acres are planted in cool areas in Sonoma. It is the darling of many wine aficionados for its versatility in being made bone dry, in slightly fruity style, or in an extremely sweet late-harvest version if left on the vine and attacked by the sweetness-inducing mold known as botrytis.

❧ Dry style with Grilled Reichardt Duck Farm (Petaluma) duck breasts. ❧ Late-harvest style with Giorgi's (Santa Rosa) Cheesecake.

Late harvest: Denotes a dessert-sweet wine whether made with Riesling, Gewürztraminer, Muscat Canelli, Semillon, Sauvignon Blanc, or Zinfandel. ❧ Pears, peaches, apricots, or plums from farm stands anywhere in the county.

Melon (de Bourgogne): Known as Muscadet in western France, this white grape has a crisp clean taste that is great with shellfish; grows close to the coast. ❧ Bay Bottom Beds (Santa Rosa) oysters on the halfshell.

Meritage: Derived from "merit" and "heritage" this is an American designation given to wines produced in the Bordeaux style and using only the Bordeaux varieties. Red wines include: Cabernet Franc, Cabernet Sauvignon, Malbec, Merlot, and Petite Verdot; whites: Sauvignon Blanc and Semillon. Flavors are rich, and the wines are made like reserve wines with potential for long aging. ❧ Sonoma Foie Gras (Sonoma).

Merlot: Nearly 3,000 acres grow in Sonoma and more are being planted. This is the second most popular red grape in Bordeaux and is often blended with Cabernet Sauvignon to give it more of a fruity and supple character. Grows well in the Alexander Valley, Dry Creek Valley, Sonoma Mountain, and Sonoma Valley viticultural areas. ❧ Piotrkowski Poultry (Petaluma) smoked duck.

Mourvèdre: A red grape from the south of France with a name like a Shakespearian character. As the Rhône varietals increase in popularity more of this grape will be found both blended and as a varietal. It has a deep rich color and slightly tart flavor. ❧ Angelo's Meats (Petaluma) beef jerky or smoked turkey.

Muscat Canelli: A white grape usually made into low alcoholic or fortified sweet white wine. There are just under 50 acres in Sonoma County; Chateau Souverain has 4½ acres in front of the winery. ❧ Gravenstein apple pie from Mom's Pies (Sebastopol) or Hallberg's Apple Farm (Sebastopol).

Napa Gamay: See Valdiguié.

Nebbiolo: One of the two top red grapes in the Piedmont region of Italy (with Sangiovese), where it is known as Barolo. There are small plantings in Alexander Valley. It makes a wine that is a critic's delight in roundness and complexity. ❧ Sonoma Cheese Factory (Sonoma) Telemé or Sonoma Jack and Sonoma French Bakery (Sonoma) French bread.

Petite Sirah: A California name given to Durif, a French grape; 340 acres of it exist in Sonoma and most are old vines producing inky, peppery, slightly tannic wine that goes well with pasta, meat, and potatoes. ❧ Char-grilled Los Arroyos Ranch (town of Sonoma) beef steaks.

Petite Verdot: One of the Bordeaux five, this grape is hard to grow and is used in small amounts in blends. Geyser Peak is one winery bottling it separately to show how it tastes, which is tannic and ashy with great dark color. Not a great food wine, but interesting to sample with a little cheese. ❧ Vella Cheese Company (Sonoma) aged Cheddar.

Pinot Noir: A versatile grape perfect as the foundation for sparkling wine and as a varietal on its own; 3,100 acres are planted in Sonoma. The Carneros and Russian River viticultural areas are famous for Pinot Noir. It is characterized by the aroma and aftertaste of blackberries and raspberries. ❧ Broiled CK Lamb (Healdsburg) chops.

Port: Sweet fortified wine made in Sonoma from Zinfandel and other red grapes; perfect for serving after dinner on a blustery night. ❧ Peter Rabbit Chocolates (Santa Rosa).

Rosé: Pink wine made from red grapes that are harvested and kept with their skins long enough to extract a little color. Usually has fresh fruity flavor and is not always sweet. Rhône-style rosé is quite dry and goes with many dishes, especially seafood and poultry. ❧ Roasted Willie Bird Turkey (Santa Rosa).

Sangiovese: The principle grape in Italy's famous Chianti is attracting attention in Sonoma, where a few acres are being experimentally planted in the Alexander Valley. A great food wine. ❧ Catelli (Geyserville) ravioli with Timber Crest Farms (Healdsburg) Sonoma Dried Tomato Pasta Sauce.

Sauvignon Blanc: California's second favorite white wine grape makes an all-purpose wine most commonly described as grassy. There are 1,700 acres of it, all over Sonoma. The best wines come from the Dry Creek Valley and Sonoma Valley viticultural areas. ❧ Sonoma Gourmet (Kenwood) Ginger Chutney with grilled Sonoma County chicken.

Semillon: About 175 acres of this white grape are planted in Sonoma. The bland flavor makes it better for blending (with Sauvignon Blanc) than bottling as a varietal. In France, it becomes the famous Sauternes when botrytis turns it opulently sweet for dessert wine. ❧ Salsa from La Casa Foods (Sonoma) or La Tortilla Factory (Santa Rosa).

Sparkling wine: If the label reads *méthode champenoise* this is Champagne. Most wineries, in deference to the French law allowing "Champagne" on the label only if the wine comes from the Champagne region, call their bottle-fermented output sparkling wine. Sonoma sparklers are made from blends of Chardonnay and Pinot Noir and sometimes a little Pinot Meunier. Flavors range from dry (brut) to sweet (sec and demi-sec). Sparkling wines go with any food. ❧ Strawberries from Happy Haven Ranch (Sonoma).

Symphony: A white grape original developed by the University of California at Davis; it is a cross of Grenache Gris and Muscat of Alexandria. The biggest producer is Chateau de Baun, near Santa Rosa, which makes wines from sweet to dry to sparkling from it. ❧ Dry style with Mediterranean Gourmet (Santa Rosa) hummus.

Syrah: Small amounts of this red grape are being experimented with in the Alexander Valley and a few other locations in Sonoma County. Another of the Rhône varietals, it promises to gain increased attention as winemakers make more of the varietal, showcasing its peppery and black currant flavors. ❧ Laura Chenel (near the town of Sonoma) aged chevre and focaccia from Artisan Bakery (of Sonoma).

Valdiguié: A grape from the French Midi, it is known as Napa Gamay in California and there are about 230 acres planted in Sonoma. The flavor is light, with a balance of fruit and acid. A good all-purpose quaffing wine. ❧ Mezzetta Brand olives (Sonoma) and Mezzaluna Bakery (Santa Rosa) European breads.

Viognier: A white Rhône varietal of which very little is planted worldwide. It is being experimented with in several vineyards in Sonoma and offered as a wine by the glass in local restaurants to introduce patrons to the taste, which runs from dry with the hint of peaches and apricots to tart like grapefruit. It has the distinction of being blended into red Rhône wines. ❧ Sonoma brand (Petaluma) Garlic Dip and Cousteaux (Healdsburg) French bread.

Zinfandel: Of uncertain origins, Zinfandel is California's adopted varietal, and Sonoma is its mother. Acres of hundred-year-old vines are found in the Dry Creek Valley, Alexander Valley, and Sonoma Valley viticultural areas; this maturity gives great body and depth to the already spicy and berry-rich flavors of the robust wine. Pair it with equally rich and robust food. ❧ Mendocino Pasta Company (Cotati) Garlic and Basil Rotelle with Sonoma Gourmet (in town of Sonoma) Garlic Tomato sauce.

Sources for this list include Sonoma County wineries, *The New Connoisseur's Book of California Wines*, by Norman Roby and Charles Olken, and *The New Frank Schoonmaker Encyclopedia of Wine*, by Alexis Bespaloff; Sonoma Valley Wineries Association, Sonoma County Farm Trails, and Sonoma County Agricultural Marketing Program (SCAMP). Many of the products listed are found in grocery stores and specialty food markets. For producers' addresses and phone numbers call area 707 information or request a list from Farm Trails or SCAMP (listed under Resources).

RESOURCES

*Note: all resources
are in the 707 telephone
area code.*

FOR EDUCATION

Sonoma County Wine and
Visitors Center
5000 Roberts Lake Road
Rohnert Park 94928
586-3795

Sonoma County Wine Library
Healdsburg Regional Library
139 Piper Street
Healdsburg 95448
433-3772

FOR HISTORY

Bartholomew Memorial Park
Old Winery Road
(P.O. Box 311)
Sonoma 95476
938-2244

Cloverdale Historical Museum
215 N. Cloverdale Boulevard
Cloverdale 95425
894-2067

Fort Ross State Historic Park
Highway 1, 12 miles north of
Jenner
(P.O. Box 123)
Duncans Mills 95430
847-3286

The Healdsburg Museum
221 Matheson Street
Healdsburg 95448
431-3325

Jack London State Historic Park
2400 London Ranch Road
Glen Ellen 95442
938-5216

Luther Burbank Home & Garden
Santa Rosa Avenue at
Sonoma Avenue
P.O. Box 1678
Santa Rosa 95402
524-5445

Luther Burbank's Gold Ridge
Farm
To visit write to:
Western Sonoma Historical
Society
Attn: Farm Committee
P.O. Box 816
Sebastopol 95473

Mission San Francisco
de Solano
20 East Spain Street
Sonoma 95476
938-1519

Petaluma Adobe State Park
(General Vallejo's 1836 home)
3325 Adobe Road
Petaluma 94953
762-4871

Sonoma County Museum
425 Seventh Street
Santa Rosa 95401
579-1500

FOR TOURING

Sonoma County Convention &
Visitors Bureau
5000 Roberts Lake Road,
Suite A
Rohnert Park 94928
586-8100

Sonoma Valley Visitors Bureau
453 First Street E.
Sonoma 95476
996-1090

FOR GRAPE GROWING AND FARM PRODUCE

Sonoma County Agricultural
Commission
2604 Ventura Avenue,
Room 101
Santa Rosa 95403
525-2371

Sonoma County Agricultural
Marketing Program (SCAMP)
1055 W. College Avenue, #194
Santa Rosa 95401
571-8894

Sonoma County Farm Bureau
970 Piner Road
Santa Rosa 95401
544-5575

Sonoma County Farm Trails
P.O. Box 6032
Santa Rosa 95406
996-2154

Sonoma County Grape
Growers Association
850 Second Street, Suite C
Santa Rosa 95404
579-9272

Sonoma County Wineries
Association
5000 Roberts Lake Road
Rohnert Park 94928
586-3795

Sonoma Valley Vintners &
Growers
453 First Street E.
Sonoma 95476
935-0803

FOR WINE & FOOD EVENTS

Art Trails of Sonoma County
P.O. Box 7400
Santa Rosa 95407
579-2787

Russian River Wine Road
P.O. Box 46
Healdsburg 95448
(800) 648-9222 (in California
only) or 433-6782

Sonoma County Culinary Guild
P.O. Box 6191
Santa Rosa 95406

Sonoma County Fair Association
1350 Bennett Valley Road
(P.O. Box 1536)
Santa Rosa 95401
544-5575

Sonoma County Farmlands
Group
2435 Professional Drive, Suite A
(P.O. Box 3515)
Santa Rosa 95402
576-0162

Sonoma County Farm Markets
110 Valley Oakes Drive
Santa Rosa 95409
538-7023

Sonoma County Harvest Fair
1350 Bennett Valley Road
(P.O. Box 1536)
Santa Rosa 95402
545-4203

Sonoma County Wine and
Visitors Center
5000 Roberts Lake Road
Rohnert Park 94928
586-3795

IN PRINT

The Business Journal
5550 Skylane Boulevard #E
Santa Rosa 95403

California Visitor's Review
P.O. Box 92
El Verano 95433
938-0780

A Cook's Tour of Sonoma
by Michele Anna Jordan
Aris Books / Addison Wesley
 Publishing Company
New York, 1990

Healdsburg Tribune
706 Healdsburg Avenue
Healdsburg 95448
433-4451

*Napa Valley: The Ultimate
 Winery Guide*
by Antonia Allegra
Chronicle Books
San Francisco, 1993

The Paper
540 Mendocino Avenue
Santa Rosa 95401
527-1200

The Petaluma Post
P.O. Box 493
Petaluma 94953
762-3260

The Press Democrat
P.O. Box 569
Santa Rosa 95402
546-2020

The Sonoma Index Tribune
P.O. Box C
Sonoma 95476
938-2111

Sonoma Style Magazine
452 B Street
Santa Rosa 95405
579-8418

Sonoma Visitor
P.O. Box 1374
Eureka 95502
433-4887

TO LOCATE CERTIFIED FARMERS' MARKETS

These are the locations of regularly scheduled markets of fresh fruits and vegetables sold by the farmers who grow them. For more information please call Sonoma County Farmers' Markets 538-7023.

SUNDAY

Sebastopol:
June-October
10:00 A.M.-1:00 P.M.
Weeks Way & McKinley
829-3853

TUESDAY

Healdsburg:
May-October
4:00-7:00 P.M.
North & Vine Streets
431-1956

Sonoma:
May-October
5:30 P.M.-Dusk
On the Plaza
538-7023

WEDNESDAY

Santa Rosa:
All year 8:30-11:00 A.M.
Montgomery Village
 Shopping Center
538-7023

Santa Rosa:
All year 9:00 A.M.-Noon
Santa Rosa Vets' Memorial
 Building off Highway 12
 (Sonoma Highway)
523-0962

Windsor:
mid-June-October
4:00-6:30 P.M.
Windsor Palms & Plaza 1
431-1956

THURSDAY

Santa Rosa:
late May-Labor Day
5:30-8:00 P.M.
4th Street between
 B & E Streets
544-4980

FRIDAY

Sonoma
All year
9:00 A.M.-Noon
Depot Park on First Street W.
538-7023

SATURDAY

Healdsburg:
May-December
9:00 A.M.-Noon
North & Vine Streets
431-1956

Kenwood:
All year
9:00-11:30 A.M.
8112 Sonoma Highway
 (Highway 12) in
 Kenwood Center
538-7023

Petaluma:
June-October
2:00-5:00 P.M.
Petaluma Boulevard S. at
 Walnut Park
762-0344

Rohnert Park:
All year 5:00-8:00 P.M.
Raley Town Center
538-7023

Santa Rosa:
All year
9:00 A.M.-Noon
Santa Rosa Vet's Memorial
 Building, off Highway 12
 (Sonoma Highway)
523-0962

A Directory of
Sonoma County Wineries

*Unless noted otherwise,
all telephone numbers are in
707 Area Code.*

Adler Fels Winery

5325 Corrick Lane
Santa Rosa 95405
539-3123
Ch, Gw, FB, SW
Hours by appointment
Tours by appointment
Picnic area: no

Albini Family Vineyards

886 Jensen Lane
Windsor 95492
838-9249
M
Call for hours

Alderbrook Winery

2306 Magnolia Drive
Healdsburg 95448
433-9154
Ch, SB, Se, Gw, PS, LH
Hours 10-5
Tours by appointment
Picnic area: yes

Alexander Valley Fruit & Trading Co.

5110 Highway 128
Geyserville 95441
433-1944
Ch, SB, WZ, LH, Ca, CS, Z
Hours 10-5
Tours by appointment
Picnic area: yes

Alexander Valley Vineyards

8644 Highway 128
Healdsburg 95448
433-7209
Ch, CB, Gw, JR, M, PN, CS, Z
Hours 10-5
Tours by appointment
Picnic area: yes

Annapolis Winery

26055 Soda Springs Rd.
Annapolis 95412
886-5460
SB, Gw, CS
12-5 ~ Thurs.-Mon.
Tours by appointment
Picnic area: yes

Armida Winery

2201 Westside Road
Healdsburg 95448
433-2222
Ch, M, PN
Hours 10-5
Tours by appointment
Picnic area: yes

Arrowood Vineyards & Winery

14347 Sonoma Highway
Glen Ellen 95442
938-5170
Ch, CS, M
Hours 10-2
Tours by appointment
Picnic area: no

Bandiera Winery

8860 Highway 12
Kenwood 95442
894-4295
Ch, LH, CS, M
Hours 10-4:30
Tours by appointment
Picnic area: no

Bartholomew Park Winery

1000 Vineyard Lane
Sonoma 95476
935-9511
Ch, CS
Hours 10-4:30
Picnic area: yes

Bellerose Vineyards

435 W. Dry Creek Road
Healdsburg 95448
433-1637
Ch, CF, SB, CS, PV, M
Hours 11-4:30
Tours by appointment
Picnic area: yes

Belvedere Winery

4035 Westside Road
Healdsburg 95448
433-8236
Ch, LH, CS, M, Z
Hours 10-4:30
Tours by appointment
Picnic area: yes

Benziger Family Winery

1883 London Ranch Road
Glen Ellen 95442
935-3000
Ch, FB, Se, CF, CS, M
Hours 10-4:30
Self guided & 2 guided tours daily
Picnic area: yes

Braren Pauli Winery

1611 Spring Hill Road
Petaluma 94952
778-0721
Ch, Gw, CS, M
Hours by appointment
Tours by appointment
Picnic area: no

Buena Vista Carneros

18000 Old Winery Road
Sonoma 95476
938-1266
Ch, Gw, SB, CS, GB, M, PN
Hours 10:30-5
Tours 2:00 M-F
 11:30 & 2 Sat & Sun
Picnic area: yes

Davis Bynum Winery

8075 Westside Road
Healdsburg 95448
433-5852
Ch, FB, Gw, CS, PN, M, Z
Hours 10-4:30
Tours by appointment
Picnic area: yes

Cale Cellars

2501 Barona Place
Santa Rosa 95405
526-2253
Ch
Not open to the public

Canyon Road Winery

19550 Geyserville Avenue
Geyserville 95441
857-3417
Ch, SB, CS
Hours 10-5
Tours by appointment
Picnic area: yes

Chalk Hill Winery

10300 Chalk Hill Rd.
Healdsburg 95448
838-4306
Ch, SB, CS
Hours by appointment
Tours by appointment
Picnic area: no

CHANDELLE OF SONOMA

14301 Arnold Drive
Glen Ellen 95442
938-5862
Ch, CS
Hours 10-5 M-F
11-2 Sat & Sun
Picnic area: no

CHATEAU DE BAUN

5007 Fulton Road
Fulton 95439
571-7500
Ch, Sym, PN, SW
Hours 10-5
Tours by appointment
Picnic area: yes

CHATEAU ST. JEAN

8555 Sonoma Highway
Kenwood 95452
833-4134
Ch, FB, Gw, JR, PN, CS, SW
Hours 10-4:30
Self-guided tours
Picnic area: yes

CHATEAU SOUVERAIN

Independance Lane at
 Highway 101
Geyserville 95441
433-8281
Ch, SB, CS, M, PN, Z
Hours 10-5 ~ Wed-Mon
Tours: none
Picnic area: no

CHRISTOPHER CREEK WINERY

641 Limerick Lane
Healdsburg 95448
433-2001
Sym, PS
Hours 11-5
Tours by appointment
Picnic area: no

CLINE CELLARS

24737 Arnold Dr. (Hwy. 121)
Sonoma 95476
935-4310
Se, R, Ca, Mo, Sy, Z
Hours 10-6
Tours by appointment
Picnic area: yes

CLOS DU BOIS

5 Fitch Street
Healdsburg 95448
433-5576
Ch, Gw, SB, CS, M, PN
Hours 10-4:30
Tours by appointment
Picnic area: no

B.R. COHN

15140 Sonoma Highway
Glen Ellen 95442
938-4064
Ch, CS, M
Hours 10-5
Tours by appointment
Picnic area: yes

DEHLINGER

6300 Guerneville Rd.
Sebastopol 95472
823-2378
Ch, CF, CS, PN
Hours 10-5
Tours by appointment
Picnic area: no

DeLOACH VINEYARDS

1791 Olivet Road
Santa Rosa 95401
526-9111
Ch, Gw, SB, WZ, PN, CS, Z
Hours 10-4:30
Tours 2:00 M-F
11 & 2 Sat & Sun
Picnic area: yes

deLORIMIER WINERY

2001 Highway 128
Healdsburg 95448
433-7718
Ch, LH, Mrt
Hours 10-4 ~ Fri-Mon
Tours by appointment
Picnic area: yes

DeNATALE VINEYARDS

11020 Eastside Rd
Healdsburg 95448
431-8460
Ch, SB, CS, PN
Hours by appointment
Tours by appointment

DOMAINE ST. GEORGE WINERY

1141 Grant Avenue
Healdsburg 95448
433-5508
Ch, FB, WZ, CS, M
Hours 10-4
Tours by appointment
Picnic area: no

DRY CREEK VINEYARD

3770 Lambert Bridge Road
Healdsburg 95448
433-1000
Ch, CB, FB, CF, CS, M, Mrt, Z
Hours 10-4:30
Tours: none
Picnic area: yes

EAGLE RIDGE WINERY

111 Goodwine Avenue
Penngrove 94951
664-9463
Gw, MB, LH, PN, Mo
Hours 10-4:30
Tours: self-guided
Picnic area: yes

ESTANCIA VINEYARDS

4725 Highway 128
Healdsburg 95448
963-7111
CS, Mrt
Not open to the public

FERRARI-CARANO VINEYARDS AND WINERY

8761 Dry Creek Road
Healdsburg 95448
433-6700
Ch, FB, LH, CS, M, Sg, Z
Hours 10-5
Tours by appointment
 10 & 2 Mon-Sat
Picnic area: no

FIELD STONE WINERY & VINEYARD

10075 Highway 128
Healdsburg 95448
433-7266
Ch, SB, CS, PS, P, Z
Hours 10-5
Tours by appointment
Picnic area: yes

FISHER VINEYARDS

6200 St. Helena Rd.
Santa Rosa 95404
539-7511
C, CS
Tours by appointment
Picnic area: yes

FOPPIANO VINEYARDS

12707 Old Redwood Highway
Healdsburg 95448
433-7272
Ch, SB, CS, PS
Hours 10-4:30
Winery tours by appointment
Self-guided vineyard tour
Picnic area: yes

FRICK WINERY

23072 Walling Road
Geyserville 95441
415 362-1911
Ci, NG, PS, Z
Hours by appointment
Tours by appointment
Picnic area: no

J. FRITZ WINERY

24691 Dutcher Creek Road
Cloverdale 95425
894-3389
Ch, MB, SB, LH, M, Z
Hours 10:30-4:30
Tours by appointment
Picnic area: yes

E & J GALLO

P.O. Box 1130
Modesto 95353
209 579-3111
Ch, SB, CF, CS, M, Z
Not open to the public

GAN EDEN WINERY

4950 Ross Road
Sebastopol 95472
829-5686
Ch, FB, Gw, CS, PN,
Kosher wines
Not open to the public

GEYSER PEAK WINERY

22281 Chianti Road
Geyserville 95441
857-WINE
Ch, Gw, SB, JR, LH, CS, GB,
M, Mrt, P
Hours 10-5
Tours: none
Picnic area: yes

GLEN ELLEN WINERY
21468 8th Street East
Sonoma 95476
935-3010
Ch, SB, WZ, CS, GB, M
Not open to the public

GLORIA FERRER
CHAMPAGNE CAVES
23555 Highway 121
Sonoma 95476
996-7256
CH, PN, SW
Hours 10:30-5:30
Tours: hourly
Picnic area: yes

GOLDEN CREEK VINEYARDS
4480 Wallace Road
Santa Rosa 95401
538-2350
CS, M, Mrt
Hours by appointment
Tours by appointment
Picnic area: no

GUNDLACH-BUNDSCHU
WINERY
2000 Denmark Street
Sonoma 95476
938-5277
Ch, Gw, R, CF, CS, GB,
 M, PN, Z
Hours 11-4:30
Tours by appointment
Picnic area: yes

HAMBRECHT VINEYARDS
1040 Lytton Springs Road
Healdsburg 95448
431-1112
CS, Z
Hours by appointment
Tours by appointment
Picnic area: no

HANNA WINERY
5345 Occidental Road
Santa Rosa 95401
575-3330
Ch, SB, CS, M, PN
Hours by appointment
Tours by appointment
Picnic area: yes

HANZELL VINEYARDS
18596 Lomita Avenue
Sonoma 95476
996-3860
Ch, CS, PN
Hours by appointment
Tours by appointment

HOP KILN WINERY
6050 Westside Road
Healdsburg 95448
433-6491
Ch, Gw, JR, WZ, CS, Va, Z
Hours 10-5
Tours by appointment
Picnic area: yes

IRON HORSE VINEYARDS
9786 Ross Station Road
Sebastopol 95472
887-1507
Ch, FB, CS, PN, SW
Hours 10-4 Sat & Sun &
by appointment
Tours 10 & 3 by appointment
Picnic area: yes

JOHNSON'S ALEXANDER
VALLEY WINERY
8333 Highway 128
Healdsburg 95448
433-2319
C, JR, WZ, PN, Z
Hours 10-5
Tours by appointment
Picnic area: yes

JORDAN SPARKLING
WINE CO.
P.O. Box 1919
Healdsburg 95448
431-5200
SW
Not open to the public

JORDAN VINEYARD
& WINERY
P.O. Box 878
Healdsburg 95448
431-5250
Ch, CS, SW
Hours by appointment
Tours by appointment 10 & 3
Picnic area: no

JOSEPH SWAN VINEYARDS
2916 Laguna Road
Forestville 95436
573-3747
Ch, CS, PN, Z
Hours 11-4:30 Sat & Sun
Tours by appointment
Picnic area: no

KENDALL-JACKSON
TASTING ROOM
337 Healdsburg Avenue
Healdsburg 95448
544-4000
Ch, CB, Gw, JR, Mu, SB, CF,
CS, M, PN, Sy, Z
Hours 10-5
Tours: none
Picnic area: no

KENWOOD VINEYARDS
9592 Sonoma Highway (12)
Kenwood 95452
833-5891
Ch, SB, CS, M, PN, Z
Hours 10-4:30
Tours by appointment
Picnic area: no

KORBEL CHAMPAGNE
CELLARS
13250 River Road
Guerneville 95446
887-2294
Ch, PN, SW
Hours 9-5
Tours: hourly
Picnic area: yes

KUNDE ESTATE WINERY
10155 Sonoma Highway (12)
Kenwood 95452
833-5501
Ch, Gw, LH, CS, M, Z
Hours 11-5
Cave tours weekends & by
appointment
Picnic area: yes

LA CREMA TASTING ROOM
337 Healdsburg Avenue
Healdsburg 95448
433-4474
Ch, PN
Hours 10-5
Picnic area: no

LAKE SONOMA WINERY
9990 Dry Creek Road
Geyserville 95441
431-1550
Ci, SB, LH, WZ, CS, M, Z
Hours 10-5
Tours by appointment
Picnic area: yes

LAMBERT BRIDGE WINERY
4085 West Dry Creek Rd.
Healdsburg 95448
431-9600
Ch, FB, CS, M, Z
Hours 10-5
Picnic area: yes

LANDMARK VINEYARDS
101 Adobe Canyon Rd.
Kenwood 95452
833-0053
Ch
Hours 10-4:30
Tours by appointment
Picnic area: yes

LAUREL GLEN VINEYARD
P.O. Box 548
Glen Ellen 95442
526-3914
CS
Not open to the public

LAURIER
8132 Speer Ranch Road
Forestville 95436
887-9463
Ch
Hours by appointment
Tours by appointment
Picnic area: no

LYTTON SPRINGS WINERY
650 Chiquita Road
Healdsburg 95448
433-7721
Ch, SB, M, Z
Hours 10-4
Tours by appointment
Picnic area: no

MACROSTIE WINERY
17246 Woodland Avenue
Sonoma 95476
996-4480
Ch, M, PN
Hours by appointment
Tours by appointment
Picnic area: no

MARIMAR TORRES ESTATE
10400 Graton Road
Sebastopol 95472
823-4365
Ch, PN
Hours by appointment
Tours by appointment
Picnic area: no

MARK WEST
ESTATE WINERY
7010 Trenton-Healdsburg Road
Forestville 95436
544-4813
Ch, Gw, PN
Hours 10-5
Tours by appointment
Picnic area: yes

MARTINELLI WINERY
3360 River Road
Windsor 95492
525-0570
800/346-1627
Ch, Gw, SB, WZ, Z
Hours 10-5
Tours by appointment
Picnic area: yes

MARTINI & PRATI
2191 Laguna Road
Santa Rosa 95401
823-2404
Ch, CB, Mu, Bu, CS, PN, P,
 & Sherry & Sweet Vermouth
Hours 11-4
Picnic area: no

MATANZAS CREEK WINERY
6097 Bennett Valley Road
Santa Rosa 95404
528-6464
Ch, SB, M
Hours 10-4 M-S, 12-4 Sun
Self-guided garden tours.
Winery tours by appointment
Picnic area: yes

MAZZOCCO VINEYARDS
1400 Lytton Springs Road
Healdsburg 95448
433-9035
Ch, CS, M, Mrt, Z
Hours 10-4
Tours by appointment
Picnic area: no

THE MEEKER VINEYARDS
9711 W. Dry Creek Road
Healdsburg 95448
431-2148
Ch, CS, Z
Irregular hours daily and by
 appointment
Picnic area: yes

MELIM / MAÁCAMA
CREEK VINEYARD
15001 Chalk Hill Road
Healdsburg 95448
433-2148
Ch, CS
Hours by appointment
Tours by appointment
Picnic area: yes

THE MERRY VINTNERS
3339 Hartman Road
Santa Rosa 95401
526-4441
Ch
Hours by appointment
Tours by appointment
Picnic area: no

MICHEL-SCHLUMBERGER
/DOMAINE MICHEL
4155 Wine Creek Road
Healdsburg 95448
433-7427
Ch, CS, M
Hours by appointment
Tours 11 & 2 by appointment
Picnic area: no

MILL CREEK VINEYARDS
1401 Westside Road
Healdsburg 95448
433-5098
Ch, Gw, CS, M
Hours 10-4:30
Tours: none
Picnic area: yes

ROBERT MUELLER CELLARS
120 Foss Creek Circle
Healdsburg 95448
431-1353
Ch, WZ, CS
Hours 10-4:30 Closed Sunday
Tours by appointment
Picnic area: no

MURPHY-GOODE
ESTATE WINERY
4001 Highway 128
Geyserville 95441
431-7644
Ch, FB, CS, M, PN
Hours 10:30-4:30
Tours by appointment
Picnic area: no

ONE WORLD WINERY
2948 Piner Road
Santa Rosa 95401
525-0390
Ch, CS
Hours vary and by appointment
Picnic area: yes

OPTIMA WINE CELLARS
498 Moore Lane
Healdsburg 95448
431-8222
Ch, CS
Hours by appointment
Tours by appointment
Picnic area: no

PARADISE RIDGE WINERY
4545 Thomas Lake Harris Drive
Santa Rosa 95403
528-9463
Ch, SB
Hours 11-5
Tours: none
Picnic area: yes

J. PEDRONCELLI WINERY
1220 Canyon Road
Geyserville 95441
857-3531
Ch, CB, FB, WZ, CS, GB,
 M, PN, Z
Hours 10-5
Tours by appointment
Picnic area: yes

PELLIGRINI FAMILY/OLIVET
LANE ESTATE
4055 West Olivet Road
Santa Rosa 95401
415 761-2811
Ch, CS, PN
Hours by appointment
Tours by appointment
Picnic area: no

PETER MICHAEL WINERY
12400 Ida Clayton Road
Calistoga
942-4459
Ch, SB, CS
Hours by appointment
Tours by appointment
Picnic area: no

PIPER SONOMA
11447 Old Redwood Highway
Healdsburg 95448
433-6321
SW
Hours 10-5
Self-guided tours
Picnic area: yes

PORTER CREEK VINEYARDS
8735 Westside Road
Healdsburg 95448
433-6321
Ch, PN
Hours 10:30-4:30 June-Sept.
Winter: weekends only

PRESTON VINEYARDS
9282 West Dry Creek Road
Healdsburg 95448
433-3372
CB, SB, Vi, GB, Ba, CS, Z
Hours 12-4 M-F
Tours by appointment
Picnic area: yes

QUIVIRA VINEYARDS
4900 West Dry Creek Road
Healdsburg 95448
431-8333
SB, CS, M, Z
Hours 10-4:30
Tours by appointment
Picnic area: yes

RABBIT RIDGE WINERY
3291 Westside Rd.
Healdsburg 95448
431-7128
Ch, CF, Z, M
Hours 11-5
Tours by appointment
Picnic area: yes

A. RAFANELLI WINERY
4685 West Dry Creek Road
Healdsburg 95448
433-1385
CS, Z
Hours by appointment
Tours by appointment
Picnic area: yes

RAVENSWOOD WINERY
18701 Gehricke Rd.
Sonoma 95476
938-1960
Ch, CS, M, Z
Hours 10-4:30
Tours by appointment
Picnic area: yes

ROCHE WINERY
28700 Highway 121
Sonoma 95476
935-7115
Ch, Mu, M, PN
Hours 10-5
Tours by appointment
Picnic area: yes

ROCHIOLI VINEYARDS
6192 Westside Road
Healdsburg 95448
433-2305
Ch, Gw, SB, PN
Hours 10-5
Tours by appointment
Picnic area: yes

RODNEY STRONG VINEYARDS
11455 Old Redwood Highway
Healdsburg 95448
431-1533
Ch, SB, CS, M, PN, Z
Hours 10-5
Tours 11, 1 & 3
Picnic area: yes

ST. FRANCIS WINERY
8450 Sonoma Highway (12)
Kenwood 95452
833-4666
Ch, Gw, CS
Hours 10-4:30
Tours: none
Picnic area: yes

SAUSAL WINERY
7370 Highway 128
Healdsburg 95448
433-2285
WZ, CS, Z
Hours 10-4
Tours: none
Picnic area: yes

**SCHUG CARNEROS
ESTATE WINERY**
602 Bonneau Road
Sonoma 95476
939-9363
Ch, M, PN, Z
Hours 10-5
Tours by appointment
Picnic area: no

SEA RIDGE WINERY
13404 Dupont Road
Occidental 95465
874-1707
Ch, M, PN, Z
Hours 11-4
Tours by appointment
Picnic area: yes

SEBASTIANI VINEYARDS
389 Fourth Street East
Sonoma 95476
938-5532
Ch, LH, Ba, CF, CS, M, Mo,
Sy, Z
Hours 10-5
Tours: continuous
Picnic area: yes

SEGHESIO WINERY
14730 Grove Street
Healdsburg 95448
433-3579
Ch, SB, WZ, CS, PN, Sg
Hours by appointment
Tours by appointment
Picnic area: no

SILVER OAK CELLARS
Alexander Valley
24625 Chianti Road
Geyserville 95441
857-3562
CS
Hours 9-4:30 M-F
Tours 1:30 M-F by appointment
Picnic area: no

SIMI WINERY
16275 Healdsburg Avenue
Healdsburg 95448
433-6981
Ch, SB, R, CS
Hours 10-4:30
Tours 11, 1 & 3
Picnic area: yes

**SMOTHERS BROTHERS
TASTING ROOM**
9575 Sonoma Highway (12)
Kenwood 95452
833-1010
Ch, SB, Gw, CS
Hours 10-5
Picnic area: yes

SONOMA CREEK WINERY
23355 Millerick Road
Sonoma 95476
938-3031
Ch, CS, M, Z
Hours 10-4 Sat & Sun
Tours by appointment

SONOMA-CUTRER VINEYARDS
4401 Slusser Road
Windsor 95492
528-1181
Ch
Hours by appointment
Tours by appointment
Picnic area: no

ROBERT STEMMLER WINERY
3805 Lambert Bridge Road
Healdsburg 95448
433-6334
PN
Hours by appointment
Tours by appointment
Picnic area: no

J. STONESTREET
TASTING ROOM
337 Healdsburg Avenue
Healdsburg 95448
433-9463
Ch, PN, M, CS
Hours 10-5
Tours by appointment
Picnic area: no

TELDESCHI CELLARS
5017 Dry Creek Rd.
Healdsburg 95448
433-1283
Z
Hours 10:30-4:30 Sat & Sun
Picnic area: no

TOPOLOS AT RUSSIAN
RIVER VINEYARDS
5700 Gravenstein Hwy.
Forestville 95436
887-1575
Ch, AB, CS, PN, PS, Z
Hours 10:30-5:30
Tours by appointment
Picnic area: no

TRELLIS VINEYARDS
P.O. Box 685
Novato 94945
800 962-3764
Ch, SB, CS
Call for information

TRENTADUE WINERY
& VINEYARDS
19170 Geyserville Avenue
Geyserville 95441
433-3104
Ch, WZ, Ca, M, P, PS, Sg, Z
Hours 10-5
Tours by appointment
Picnic area: yes

M.G. VALLEJO
21468 8th Street East
Sonoma 95476
939-6202
Ch, FB, WZ, CS, M, Z,
Not open to the public

VALLEY OF THE MOON
WINERY
777 Madrone Rd.
Glen Ellen 95442
996-6941
Ch, Se, SB, Sym, WZ, CS,
 PN, Z
Hours 10-5
Tours by appointment
Picnic area: yes

VIANSA WINERY &
ITALIAN MARKETPLACE
25200 Highway 121
Sonoma 95476
935-4700
Ch, SB, LH, Mu, CF,
 CS, N, Sg
Hours 10-5
Tours: self-guided and by
 appointment
Picnic area: yes

WEINSTOCK CELLARS
3088 Center St.
Healdsburg 95448
433-3186
Ch, SB, WZ, GB, PN
Hours by appointment
Tours by appointment

WELLINGTON VINEYARDS
11600 Dunbar Road
Glen Ellen 95442
939-0708
Ch, GW, Ab, Ca, CF, CS, M,
 MO, P, Z
Hours 12-5 Thurs-Mon
Tours by appointment
Picnic area: yes

WILLIAM WHEELER WINERY
130 Plaza Street
Healdsburg 95448
433-8786
Ch, SB, WZ, CS, M, Z
Hours 10-5
Tours by appointment
Picnic area: no

WHITE OAK VINEYARDS
208 Haydon Street
Healdsburg 95448
433-8429
Ch, CB, SB, CF, CS, Z
Hours 10-4 Fri-Sun
Tours by appointment
Picnic area: no

WILD HOG HILL
101 A Grant Avenue
Healdsburg 95448
433-7916
Ch, LH, PN
Not open to the public

WILD HOG VINEYARD
30904 King Ridge Road
Cazadero 95421
897-3687
CS, PN, PS, Z
Hours by appointment
Tours by appointment
Picnic area: no

WILLIAMS SELYEM WINERY
850 River Road
Fulton 95439
433-6425
PN, Z
Hours by appointment

WINDSOR VINEYARDS
239 A Center Street
Healdsburg 95448
433-2822
Ch, CB, Gw, JR, WZ, CS, M,
 PN, PS, Z, SW
Hours 10-5
Tours: none
Picnic area: no

Z MOORE WINERY
3364 River Road
Windsor 95492
544-3555
Ch, Gw, PN, PS, Z
Hours 10-5
Picnic area: yes

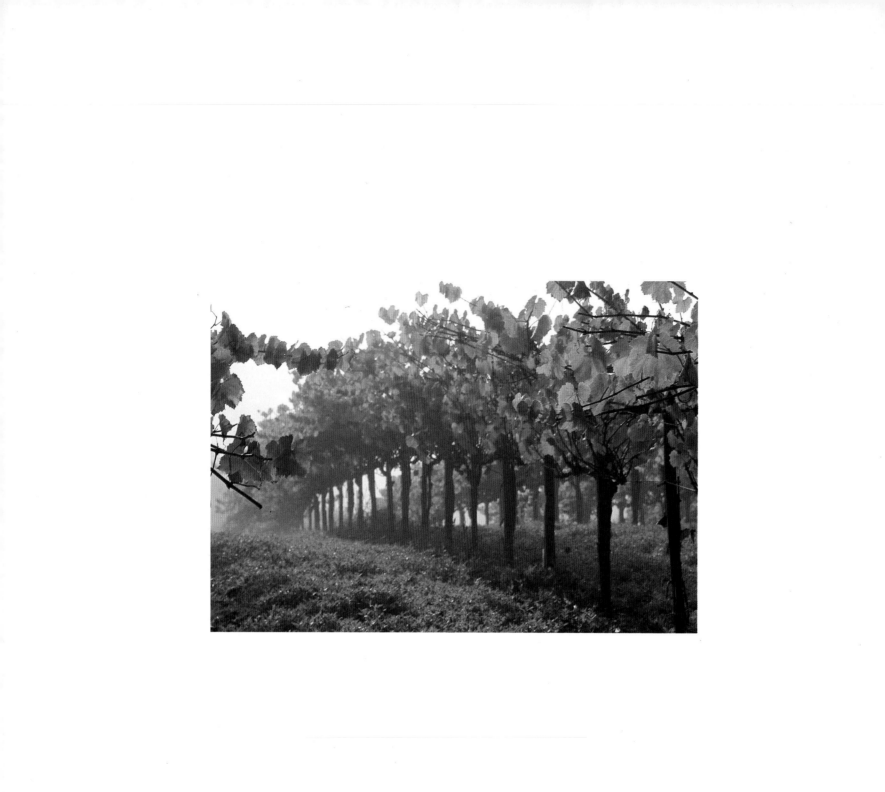